Map and Guide

National Gallery of Art
Washington

Barbara Moore Carla Brenner

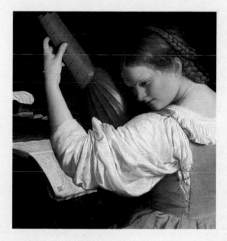

Scala Publishers in association with
the National Gallery of Art, Washington

SCALA

West Building

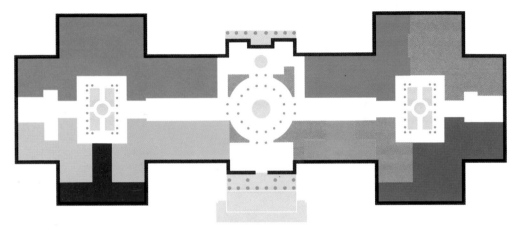

Mall entrance

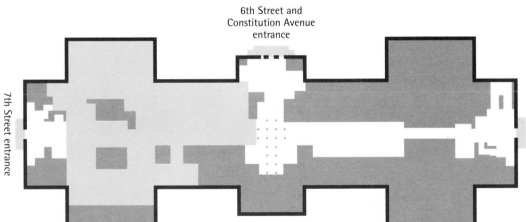

6th Street and
Constitution Avenue
entrance

7th Street entrance

4th Street entrance

Contents

East Building

Tower level

Upper level

Mezzanine

Ground level

Concourse level

East Building

55 Upper level

60 Concourse level

54, 62 Ground level

Sculpture Garden

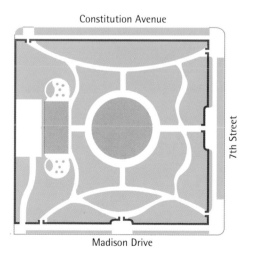

63 Sculpture garden

Preface

The vision and public service of just one man, Andrew W. Mellon, established the National Gallery of Art and determined its future direction. In 1937 Mellon gave his collection of European painting to the nation, provided funds for the museum's first building, the West Building (opened in 1941), and established an endowment fund. The United States Congress passed legislation to adopt the Gallery as a federal agency and to provide support funds. Both the nature of the collections and the public-private partnership set up by Andrew Mellon remain constants for the institution.

Mellon, who served as U.S. Secretary of the Treasury and ambassador to the Court of Saint James, envisioned an outstanding picture collection based on the example of London's National Gallery. During his ambassadorship in London he frequented the National Gallery and admired its collection. Mellon amassed an extraordinary collection of European paintings from the Renaissance through the nineteenth century, and his gifts to the Gallery were enriched by the generosity of the Gallery's other founding benefactors, Joseph Widener, Chester Dale, Samuel H. Kress, and Lessing J. Rosenwald. Mellon's daughter and son, Ailsa Mellon Bruce and Paul Mellon, shared their father's passion for art and also became renowned collectors. They provided funds for the East Building (opened in 1978). In 1999 the National Gallery opened its Sculpture Garden, given to the nation by The Morris and Gwendolyn Cafritz Foundation. The Gallery continues to acquire works of art through the generous donations of private collectors, while federal funds support its operations.

This guide provides a brief introduction to the permanent collections. It is intended as a visual guide and is a sampling of what can be seen when you visit the Gallery.

Earl A. Powell III
DIRECTOR
National Gallery of Art

Leonardo da Vinci | Florentine, 1452–1519

1 *Ginevra de' Benci*, c.1474
oil on panel
Ailsa Mellon Bruce Fund

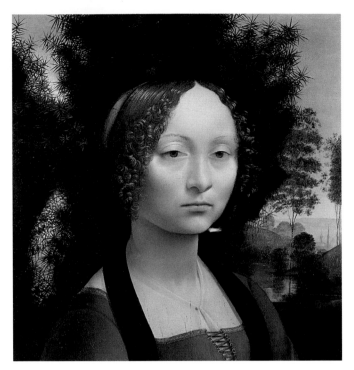

She was sixteen and sitting for a portrait that probably marked her engagement. Her painter was an aspiring artist, twenty-two years old and an assistant in the Florentine studio of the great sculptor Andrea del Verrocchio. Yet this early work, the likeness of a banker's daughter, anticipates Leonardo da Vinci's enormous contribution to the High Renaissance. He made his portrait of Ginevra de' Benci seem palpably real. Her porcelain complexion, her shiny ringlets, and the delicate modeling of her face derive from Leonardo's experimentation with oil paint, which he blended with his fingers and palms to soften the edges of forms and to create atmospheric effects. His fingerprints are visible, where the sky meets the juniper bush behind Ginevra's head.

Passionate about nature, Leonardo portrayed Ginevra literally within a landscape. Gone are conventions of the portrait genre in Europe—the figure before a window onto the world or the strict profile against a very contrived back-

ground. Ginevra is a young woman outdoors, a juniper bush directly behind her and, beyond, the misty profile of distant trees and water. Even her doleful expression and doll-like head—which may derive from Netherlandish art—rivet the impact of this, the only painting by Leonardo in the Western Hemisphere.

The back of this panel, painted to look like porphyry, is an emblematic portrait of

Ginevra. A scroll bears her Latin motto, "Beauty Adorns Virtue." A sprig of juniper (in Italian, *ginepro*) puns on Ginevra's name, while the encircling laurel and palm symbolize her intellectual and moral virtue.

Andrea del Castagno | Florentine, 1417/1419–1457

2 *The Youthful David*, c.1450
tempera on leather on wood
Widener Collection

Florence faced many Goliaths in the fifteenth century, including the pope, the doge of Venice, the king of Naples, and the duke of Milan. Smallest of the major powers in Renaissance Italy, the city identified closely with the young biblical hero David, who killed the giant with a single stone from his sling. David became a symbol of liberty—and a favorite subject for Florentine artists.

This image of David, though, is unique. It is painted on a leather parade shield. The bosses supported a handle. Such shields normally bore heraldic devices, and this one is the only known example by a master artist.

Castagno painted David in vigorous action with a strong, open outline that would have been easily read as the shield was carried. His energy and movement, underscored by windblown drapery, reveal a new interest in the human form and may have been inspired—as many early Renaissance figures were—by a famous ancient statue, one of the so-called Horse Tamers on the Quirinal in Rome.

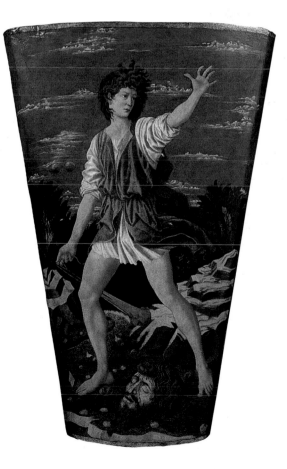

Desiderio da Settignano | Florentine, 1428/1430–1464

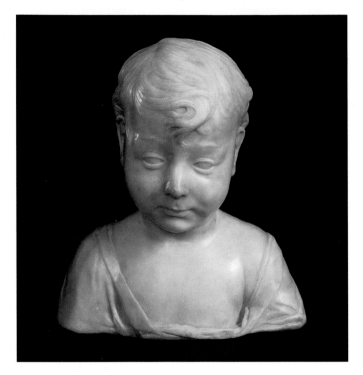

3 *The Christ Child* (?), *c.*1460
marble
Samuel H. Kress Collection

Between about 1450 and 1500, Florentine sculptors produced a remarkable group of busts of young boys. The National Gallery is fortunate to possess four of them. Many of the boys are represented in the guise of John the Baptist, patron saint of Florence, others as the Christ Child. Churchmen advised families to have such images in the home to instruct and delight the young. Some may be actual portraits. They are among the first works since antiquity to portray children as children rather than as small adults. Whether they copy the features of a particular boy or not, all are animated with life. Their vitality embodies, literally, the boys' future promise —to their families and to the Republic of Florence.

A hole for supporting a metal halo in the top of this baby's head suggests its identification as the Christ Child. He seems at once serious and barely able to suppress a smile. His cheeks are tight, his eyes now sparkling, now full of somber insight.

Giovanni Bellini | Venetian, c.1427–1516 Titian | Venetian, c.1490–1576

4 *The Feast of the Gods*,
1514/1529
oil on canvas
Widener Collection

The Feast of the Gods, as we see it today, is the work of two giants of Venetian painting, Bellini and Titian. But to a large extent, it was shaped by someone who was not an artist at all: Alfonso d'Este, duke of Ferrara. Bellini painted it for the duke's private study, called the *camerino d'alabastro*, as part of a set of bacchanals—pastoral visions of gods and goddesses that both delighted the senses and appealed to the Renaissance's reawakened interest in antiquity.

Within fifteen years substantial portions of the background had been repainted twice, first by Alfonso's court painter Dosso Dossi then by Titian. Two distinct styles can still be seen. The background on the right is painted with detailed precision. This remains from Bellini's original. On the left, the paint is brushier, freer. This is the work of Titian. Such large-scale alteration is hard to imagine today, especially to a work by an artist of Bellini's standing. Still revered as Venice's foremost painter, he had introduced the brilliant, luminous colors that would distinguish Venetian painting for centuries to come. And Titian—who painted for popes and kings—would seem an unlikely choice for "touch-up" work. The history of *The Feast of the Gods* underscores the important role played by Renaissance patrons.

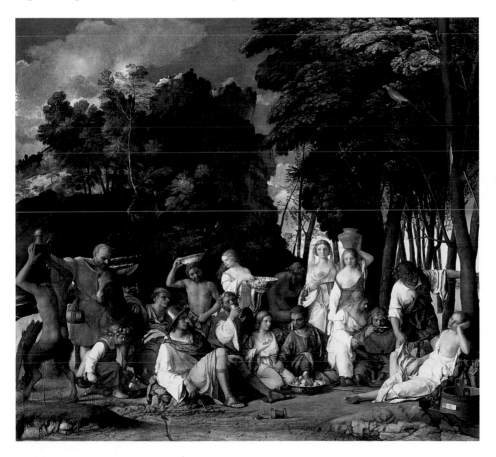

Raphael's Evolution

Raphael | Umbrian, 1483–1520

Inspired by lessons from Leonardo and Michelangelo, Raphael achieved the harmonious balance of form and content that epitomizes the High Renaissance. In this room, we can trace his evolution.

In Umbria, Raphael had first mastered the style of his teacher Perugino—gentle figures posed before silvery, poetic landscapes. When he moved to Florence in 1504, he saw firsthand works by Michelangelo and the revolutionary innovations of Leonardo da Vinci. Leonardo's softly shadowed forms captured appearances in a way never achieved before. Moreover, his figures related naturally to each other and to their physical settings. During his four years in Florence, Raphael largely supported himself by producing paintings of the Virgin and Child. Repetition proved an excellent teacher.

In 1508, Raphael moved to Rome in search of papal commissions. There, the imprint of Michelangelo's more physical style grew stronger, and the younger artist also found inspiration in the idealized, classical art of the city's ancient past.

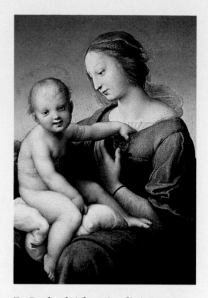

7 Raphael, *The Niccolini-Cowper Madonna,* 1508
oil on panel
Andrew W. Mellon Collection

Perhaps Raphael's last Florentine picture, *The Niccolini-Cowper Madonna* is more complex than *The Small Cowper Madonna* made only a few years before. As the playful child grabs at his mother's bodice to nurse, the two figures are linked by their interlocking pose and their intimacy. The connection is both physical and psychological. The robust infant's energetic outline, meanwhile, suggests that Raphael had begun to look at works by Michelangelo.

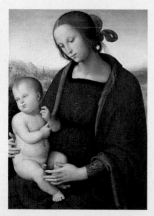

5 Perugino, Umbrian
c.1448–1524
Madonna and Child,
after 1500
oil on panel
Samuel H. Kress Collection

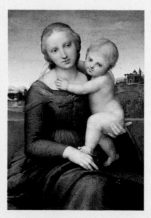

6 Raphael,
*The Small Cowper
Madonna,* c.1505
oil on panel
Widener Collection

The Small Cowper Madonna is one of the earliest of Raphael's Florentine pictures, close in style and mood to Perugino's painting. Both Virgins are graceful, with an air of wistful sentiment.

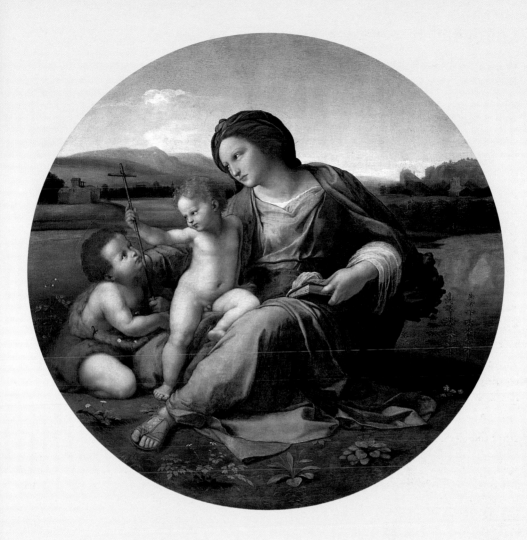

8 Raphael, *The Alba Madonna*, c.1510
oil on panel transferred to canvas
Andrew W. Mellon Collection

Where Raphael's Florentine madonnas seem intimate, the grandeur of *The Alba Madonna*, painted in Rome, suggests seriousness of purpose. The Virgin now wears ancient robes, and her pose recalls a work of classical sculpture. These full-length figures seem more "real" than do the three-quarter-length madonnas. No longer part of an iconlike devotional schema, here they are actors with real-life gestures and intent. The infant John the Baptist holds a reed cross, focus of the three figures' attention. This is not simply a formal device to unify the compositional group but conveys a specific message. By accepting it, the baby Jesus accepts his future. And his sacrifice is seen in this moment by his mother and cousin. Such balance, a seamless integration of form and meaning, is the very definition of High Renaissance art.

English, 14th or 15th Century

9 *Saint George and the Dragon*,
1370/1420
alabaster, painted and gilded
Samuel H. Kress Collection

Probably this statue was carved in England, where alabaster was abundant and where a lively trade in alabaster carvings grew up during the Middle Ages. As such, it is a rare survivor. Because it was sent to an aristocratic patron in Spain—it was in a Dominican convent there as late as 1880—it was spared the destruction suffered by most English religious images at the hands of Protestant zealots during the 1500s. The alabaster's broad smooth surfaces, crisp carving, and elegant proportions are typical of English workshop styles, though most surviving English alabasters are reliefs.

The paint and gilding are remarkably well preserved. The red cross is that of a Crusader, worn here by Saint George, who embodied the ideals of Christian chivalry. He was especially revered in England. He became England's patron saint after Richard the Lionheart (d.1199) called on his protection against Salah al-Din during the Third Crusade.

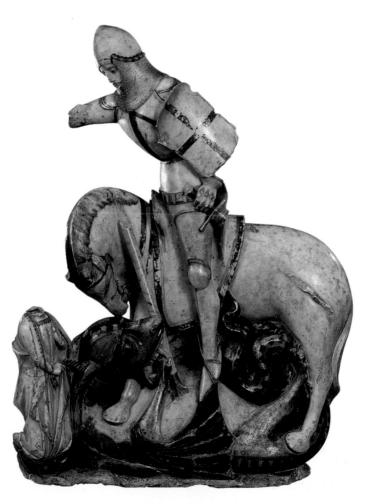

Rogier van der Weyden | Netherlandish, 1399/1400–1464

10 *Portrait of a Lady*, c.1460
oil on panel
Andrew W. Mellon Collection

The emotional pitch of Rogier's paintings were of enormous influence on other Netherlandish artists. Our impression of this sitter's psychological reality is stronger, really, than that of her physical presence, despite the portrait's meticulous style. With eyes downcast and fingers pressed nervously together, her thoughts seem elsewhere. Her concentration is intense but somehow disconnected. The brittle and elegant pattern of white triangles helps to abstract her and detach her from the present.

Since she is not shown in prayer—typical in devotional works—this is probably an independent portrait. The woman's three-quarter turn communicates greater individuality than the profile poses common only a few decades before, but we do not know who she was.

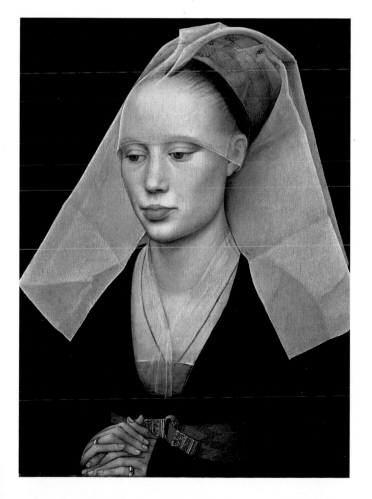

Reenacting the Annunciation

Jan van Eyck | Netherlandish, c.1390–1441

Van Eyck was among the earliest painters to perfect the techniques of oil painting, applying pigments in thin, translucent layers that trap and reflect light. It is hard to believe that we are not seeing gold, but only yellow pigment, not pearls, only paint.

Such astonishing detail—which operates at the limits of human vision—makes van Eyck's painting a concrete part of the present. The precision contributes to a tangible sense that the painted world is continuous with the viewer's own. It is a style that mirrored—and supported—the *devotio moderna*, the empathetic piety that arose in the Low Countries at the end of the Middle Ages and emphasized direct, personal identification with holy figures.

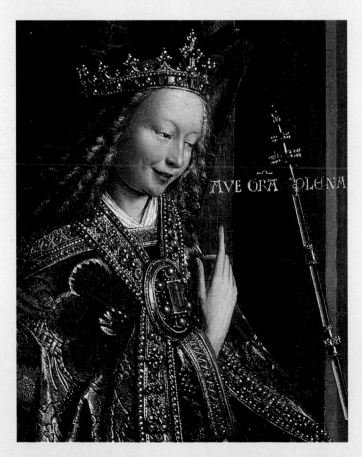

11 *The Annunciation*, c.1434/1436
oil on canvas transferred from panel
Andrew W. Mellon Collection

Mary draws back with modesty and surprise at Gabriel's salutation: *Ave gratia plena* [hail, full of Grace]. Her response is written upside down for God to see: *Ecce ancilla Domini* [Behold, the handmaiden of the Lord]. The angel has announced that Mary will bear the son of God, and she has accepted her role. The Holy Spirit descends to her on seven rays of light.

For Christian believers, this is the very moment when God's plan for mankind's salvation is put in motion—and it was a moment fifteenth-century worshipers in the Low Countries could see reenacted each Christmas season in church. During the Golden Mass, when it was time for the Gospel reading (from Luke, where the story of the Annunciation is told), sweet-faced young boys playing the roles of Gabriel and Mary stepped forward. The first pointed with a scepter and recited the angelic salutation, the same words that are inscribed on this painting. The boy playing the Virgin held his hands out in the same open gesture of prayer and blessing, following with Mary's humble response. Just as we see in van Eyck's painting, a dove was lowered from above. This Annunciation, set in a church,

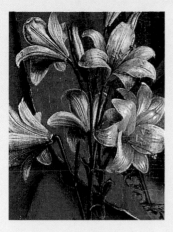

so closely matches the "stage directions" for the Golden Mass that contemporaries must have understood the association.

The painting is layered with symbolic meaning. Lilies allude to the Virgin's purity; floor designs depict Old Testament prefigurations of Jesus' life. The seven rays of light that descend to the Virgin refer to the seven benefits of the Holy Spirit. The architecture, which changes from the rounded arches of the Romanesque style in the upper tiers to the pointed arches of Gothic below, marks the transition from the old Law to a new era of Grace, brought about by Christ's human life and resurrection. Even the size of the figures, which seem out of scale, probably has symbolic purpose, underscoring the Virgin's importance as intercessor for the prayers of men and establishing an identity between Mary and the Church.

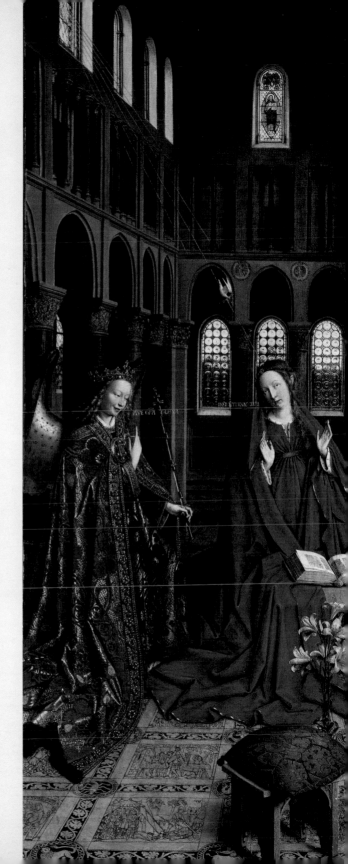

Matthias Grünewald | German, c.1475/1480–1528

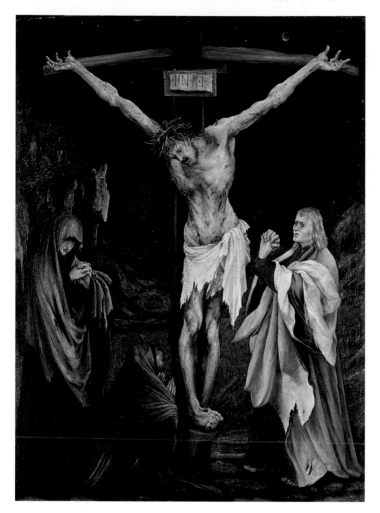

12 *The Small Crucifixion*,
c.1511/1520
oil on panel
Samuel H. Kress Collection

His fingers are contorted by pain, toes clenched in agony. The dead weight of his gangrenous body has bowed the arms of the cross. Grünewald wants us to share viscerally in Christ's final suffering. The eerie light, harsh colors, and jagged edges of rent cloth—all are meant to help us experience Christ's pain and the harrowing sadness of mourners Mary, Mary Magdalene, and John the Evangelist.

Many of the details in this scene correspond to the descriptions of the Passion recorded by the visionary Saint Bridget (d.1373). Such intense and personal identification with Christ was key to a new kind of piety that arose in northern Europe during the years before the Protestant Reformation. In Germany it had a strongly mystical character that was well matched by Grünewald's highly keyed and expressionistic images.

Adriaen de Vries | Florentine, 1556–1626

13 *Empire Triumphant over Avarice*, 1610
bronze
Widener Collection

Holding the victor's wreath, this allegory of Empire triumphs over Avarice, whose money spills out and whose ears are those of an ass, like the greedy and foolish King Midas. The figures are powerful, their interaction energetic and dynamic as they turn and gesture into space. Even the light reflecting from the bronze seems restless. De Vries was born in the Netherlands but studied and worked in Italy, and the self-conscious complexity of his statuette shows the influence of Michelangelo and Giambologna.

It was made for the Habsburg emperor Rudolph II in Prague. The puzzling theme of a triumph over avarice is probably linked to the emperor's precarious financial and political circumstances: hard pressed to pay for his wars against the Turks, Rudolph blamed his political failures on the insufficient financial support of grudging vassals and allies. Admiring this statuette in his private study, he contemplated a victory he never enjoyed in fact.

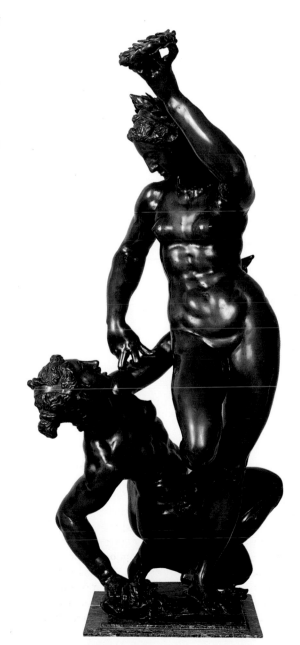

Orazio Gentileschi | Florentine, 1563–1639

14 *The Lute Player*,
*c.*1612/1620
oil on canvas
Ailsa Mellon Bruce Fund

Does this young woman listen so intently to tune her lute? Such rapt attention sometimes appears in allegories of music or hearing. But music seduces, too, and her loosened bodice ties and flushed cheek suggest that she is transported by music as if by love.

Musical themes such as this won favor among Gentileschi's sophisticated patrons in Rome, where they had been popularized by Caravaggio. Gentileschi was among the first of many artists to adapt Caravaggio's subjects and dramatic style— and one of the most inventive. Caravaggio's influence is seen in this painting's strong contrast of light and dark and its concentration on a single figure, large and close to the

front of the picture plane. Gentileschi's unique contribution is the strong diagonal arrangement and an attentive treatment of each texture: the fabrics are lustrous and rich, the wood instruments polished to a deep sheen, the woman's hair glossy and alive.

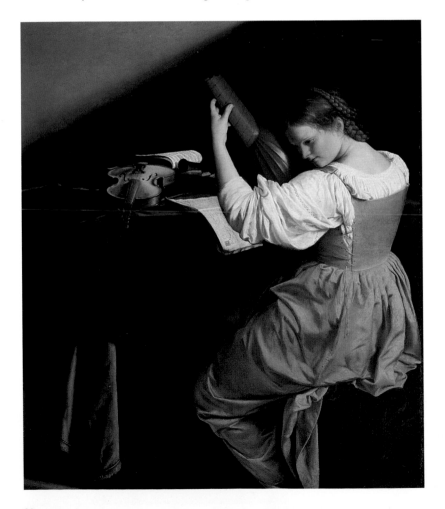

Gian Lorenzo Bernini | Roman, 1598–1680

15 *Monsignor Francesco Barberini*, c.1623
marble
Samuel H. Kress Collection

The stone is pure white yet suggests a tinge of blue under the monsignor's eyes. Its granularity, left visible rather than polished away, adds a crinkle to his linen surplice. What painters accomplish with different pigments, Bernini had to convey with the varying planes and textures of carved marble. He suggested that his was the harder task: "If a man whitens his hair, his beard, his lips and his eyebrows, and were it possible, his eyes, even those who see him daily would have difficulty recognizing him."

As it happens, it is likely that this bust was modeled after a painting, since Francesco Barberini had died many years before it was carved. Probably it was commissioned by Pope Urban VIII, Bernini's greatest patron and friend. The subject was the pope's uncle and mentor. The bust's somewhat stern reserve differs from the greater emotion seen in Bernini's later portraits, possibly reflecting the *gravitas* appropriate for an ancestral portrait as well as its posthumous production.

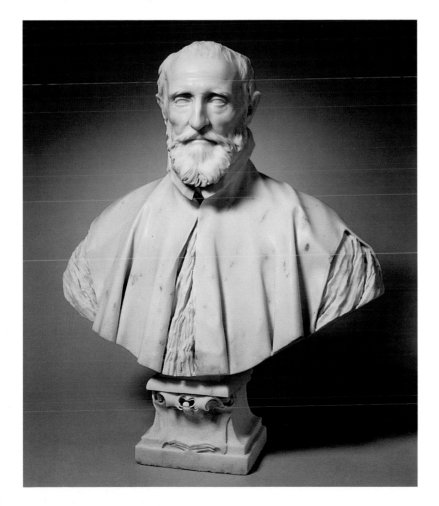

A Distinctive, Deliberate Style

El Greco | Spanish, 1541–1614

Trained as an icon-painter, El Greco—the Greek—learned Western-style painting in Venice and Rome. In Venice he acquired a love of rich colors and a sketchy manner. And in Rome he was influenced by mannerism—the elongated proportions, compressed space, intertwining poses, and bizarre colors of a style that emphasized self-conscious artifice over realistic depiction.

By 1577 El Greco had moved to Spain, where he remained for the rest of his life, working primarily for learned churchmen. His highly charged style provided powerful images to support Counter-Reformation efforts to reinforce belief in the sacraments and saints. In Toledo El Greco continued to pursue and even intensify mannerist elements of his style, while contemporaries elsewhere returned to greater naturalism. His painting—which can seem so "modern"—is rooted in sixteenth-century art.

These figures seem to loom overhead. Martina and Agnes channel the divine radiance of the Virgin and Child down to worshipers below, while Saint Martin's horse seems nearly to step into the viewer's space.

The two paintings, from one of El Greco's most important commissions, were made for Martín Ramírez, who founded the chapel where they hung. Martin of Tours, Ramírez' patron saint, was a soldier in Roman France who cut his cloak in half and shared it with a beggar on the road. Later, Christ appeared to Martin in a dream wearing the same cloak. El Greco moves the setting to Toledo and gives the fourth-century saint contemporary damascened armor. These shifts suggest that all people in Toledo, like Martín Ramírez, should emulate the saint's charity.

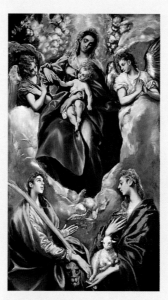

16 *Madonna and Child with Saint Martina and Saint Agnes,* 1597/1599
oil on canvas
Widener Collection

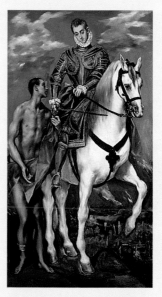

17 *Saint Martin and the Beggar,* 1597/1599
oil on canvas
Widener Collection

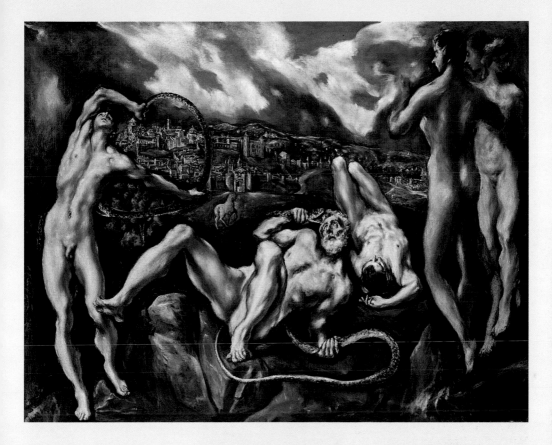

18 *Laocoön*, 1610/1614
oil on canvas
Samuel H. Kress Collection

As far as we know, Laocoön is the only subject from classical mythology that El Greco ever painted, and then only at the end of his life. This canvas seems to be one of several depicting Laocoön that were in his studio when he died.

Laocoön was a priest in Troy who attempted to warn his countrymen about accepting the Trojan Horse concealing Greek soldiers. He was punished by the gods who—for reasons that varied in the accounts of different ancient authors—sent serpents from the sea to kill him and his sons. In El Greco's powerful scene—widely recognized as a masterpiece of his late career—one son lies dead and the other will soon succumb. The old priest struggles vainly. A single break in the dead gray tones of his flesh focuses attention on his mute disbelief at his own abandonment by the gods. In the middle distance the Trojan Horse trots not toward Troy but to Toledo.

At right two figures, perhaps gods, survey the scene. (A third head and extra leg are probably sketches for an unfinished third figure.) Their ghostly presence complicates already difficult speculation about El Greco's motives (still unknown) in painting this unusual subject.

Georges de La Tour | French, 1593–1652

19 *The Repentant Magdalene,*
*c.*1640
oil on canvas
Ailsa Mellon Bruce Fund

She was a great sinner, but through penitence and contemplation became "enlightened with the light of perfect knowledge." Jesus absolved Mary Magdalene and in turn she reflected God's radiance to others. It is this light, the light of divine truth, that Georges de La Tour painted.

The single lamp illuminates only the saint's still contemplation and a few objects on the table. Most of the scene remains in deep shadow, concentrating our own meditation on a book and skull and their dim reflections in a mirror. Such dramatic contrasts of dark and light—a style that originated in the works of Italian painter Caravaggio— were highly effective in giving emotional weight to the religious images of the Counter-Reformation church. The skull, mirror, and flickering flame are all traditional symbols of the brief illusion that is man's earthly life and understanding.

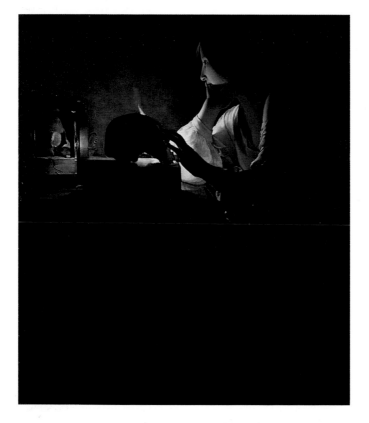

Bartolomé Esteban Murillo | Spanish, 1617–1682

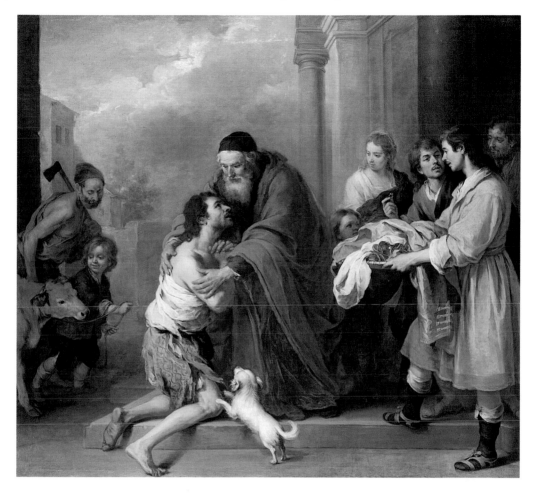

20 *The Return of the Prodigal Son*, 1667/1670
oil on canvas
Gift of the Avalon Foundation

Paintings of the Prodigal Son usually focused on the themes of forgiveness and resurrection, but this one has an added dimension. A son, having squandered his fortune in sinful living, returns home, seeking only to work in his father's house. Moved to compassion,

his father tells his servants: "Fetch quickly the best robe, and put it on him, and put a ring on his finger and shoes on his feet; and bring out the fatted calf . . . this my son was dead, and has come to life again; he was lost and now is found."

All these elements appear in Murillo's dramatic scene, one of six canvases he painted for the Hermandad de la Caridad, a lay brotherhood devoted to acts of charity. Murillo was

himself a member. Each painting illustrated one of the six acts of mercy. This one—where the son's once fine robes are now in tatters around his waist, and where bright colors are reserved for garments— also represents the act of clothing the naked.

Peter Paul Rubens | Flemish, 1577–1640

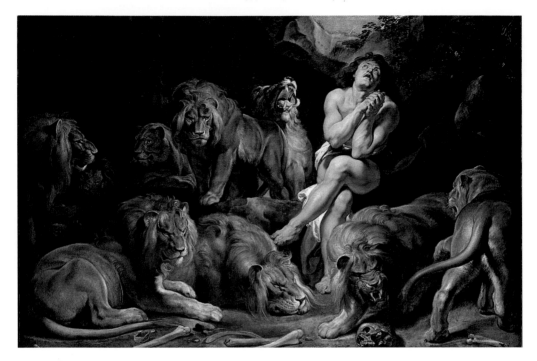

21 *Daniel in the Lions' Den,*
*c.*1613/1615
oil on canvas
Ailsa Mellon Bruce Fund

After eight years of artistic study in Italy (1600–1608), Rubens returned to his home in Antwerp, Flanders, having been influenced by antique sculpture as well as the grand manner of the Italian Renaissance. *Daniel in the Lions' Den* is a brilliant example of Rubens' expressive genius, particularly in its dramatic use of space, light, color, and scale to emphasize the physical and emotional drama of the scene. The central figure of Daniel, thrown into the lions' den by King Darius, is painted with such sculptural muscularity that he nearly trembles on the canvas. The lions are dauntingly realistic. Painted from life studies, the magnificent animals snarl, pace nervously, or lie, at least for the moment, around Daniel. Pale light entering the cave from above signals dawn and, with it, Daniel's salvation. Rubens' choice of this moment in the Old Testament story emphasizes the importance of faith and stoicism, qualities especially resonant in Catholic Flanders. Recent cleaning of the picture has revealed light streaks of blood on the snarling lion's teeth, indicating a fresh kill in the den.

Rembrandt van Rijn | Dutch, 1606–1669

22 *A Polish Nobleman*, 1637
oil on panel
Andrew W. Mellon Collection

Born in Leiden and educated there in the fundamentals of art, Rembrandt worked in that artistic center as a portraitist and history painter before moving to Amsterdam. As he is today, Rembrandt became celebrated during his career for his ability to touch the soul of a subject. You could call it emotional truth, a bracing probe of spirit that Rembrandt achieved through both temperament and style.

Rembrandt, who eschewed the ideal, was drawn, instead, to authenticity. For example, despite the impressive beaver hat and cloak worn by the Polish nobleman, a certain vulnerability is conveyed in the figure's plaintive expression— particularly in the mouth (slightly open) and the head (tilted like a near question). The sensitivity of this portrait is heightened by Rembrandt's exquisite technical range. Impasto, or thickly laid oil paint, models the sitter's face and allows light and shadow to define the wrinkles and furrowed brow. Rembrandt shifted to thinly applied paint, obviously stroked and dragged, to capture the sitter's brushy, fur jacket. Further texturing his surface while also revealing his hand at work, Rembrandt allowed areas of his ocher ground paint to show by wiping his wet oil with a cloth in the jacket and, in the beaver hat, by scratching the paint with the wood end of his brush. The effect is of an imposing, yet humane presence. Despite its title, this fanciful portrait is probably an image of Rembrandt himself.

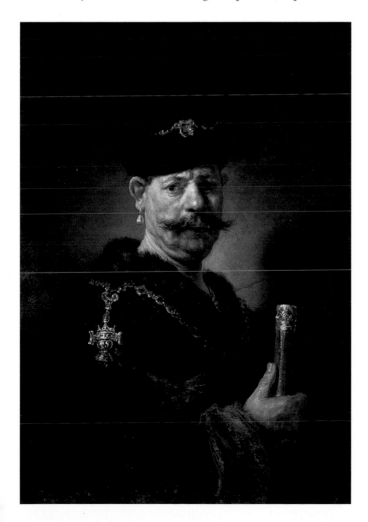

Sir Anthony van Dyck | Flemish, 1599–1641

23 *Queen Henrietta Maria with Sir Jeffrey Hudson*, 1633
oil on canvas
Samuel H. Kress Collection

Henrietta Maria, a French princess, grew up in the Louvre palace and at age fifteen was married to Charles I, king of England. Their political match, designed to ally France and England in chaotic times, had a rocky start. You see Henrietta eight years later. By then, the diffident Charles was completely devoted to his high-spirited wife. Who better to paint her than the renowned international portraitist Anthony van Dyck?

The Flemish-born van Dyck was a brilliant star in the firmament of European aristocrats, a debonair redhead who dressed and lived as grandly as his patrons. Van Dyck's portraits flattered his sitters while simultaneously expressing their elite status. His image of Henrietta epitomizes this delicate balance, so useful in validating royal status. Though described by contemporaries as extremely small, with crooked shoulders and buck teeth, Henrietta was portrayed by van Dyck as an imposing figure, with grace and beauty. He emphasized her flawless complexion and delicate hands, and boosted her stature by choosing a low vantage point and including her companion, the dwarf Sir Jeffrey Hudson. Dazzling fabrics —blue satin, ruby velvet, and gold damask— enhance her rarified allure. Sixteen years hence, Henrietta would be exiled in the Louvre, her husband beheaded following a disastrous civil war. Royal portraits rarely hint at the insecurities of life at the top.

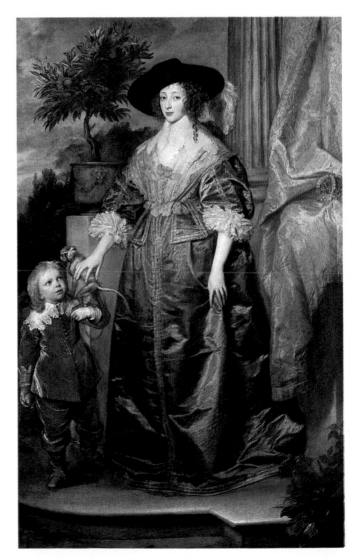

Johannes Vermeer | Dutch, 1632–1675

24 *A Lady Writing*, c.1665
oil on canvas
Gift of Harry Waldron Havemeyer
and Horace Havemeyer, Jr., in
memory of their father, Horace
Havemeyer

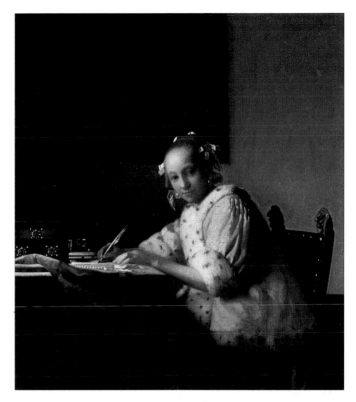

Like a candle, Vermeer's *A Lady Writing* draws you near. Her hand and quill pen still on paper, she looks up and seems to embody the welcome presence of love in her warm gaze. The painting on the wall extends the delicate emotion of the scene. Though barely discernable, it is a still life of musical instruments, which, like the writing of letters, was associated with love in seventeenth-century Dutch art. The romantic tenor of the image is realized most profoundly, however, through an equipoise of light, composition, and color.

Light glances across the inkwells, pearls, writing box, and blue velvet cloth on the table, then illuminates the woman. Darkened areas around her enhance the aura of intimacy. The composition is deft. Table and painting provide the broad forms of a horizontal-vertical framework; yet diagonals are critical. By her turning motion, her projected arm, and the angle of her chair, the woman's figure seems to cross the composition, infusing the space with human connectedness. Color is perhaps Vermeer's most magical contribution. By varying the density and touch of his paints and applying them in complex layers, he evoked the glint of light on the woman's pearls (thin gray paint daubed with highlights of thick, cream-colored oil) or the sheen of her satin jacket (two preparations of lead-tin yellow applied, one coarsely ground for the satin, the other more finely ground and also paler for highlights on the shoulder pleats). After his death, an inventory of Vermeer's household included the yellow jacket.

Dutch Still Lifes

Though ranked at the bottom of the painting hierarchy in the Netherlands during the seventeenth century, still-life paintings were hugely popular, attracted some of the best artists, and commanded high prices. These "simple" images of flowers and food had complex appeal.

Ars longa . . . In the 1600s, people living in northern Europe had few chances to enjoy blossoms in winter. Painted flowers could be admired year round. Their permanence reflects a seventeenth-century argument for the value of art—that it outlasts nature.

. . . *vita brevis*. Yet flower paintings and banquet pieces could also underline life's transience, and Dutch audiences were accustomed to reading moralizing meaning into visual images. Platters resting at a table's edge, broken vessels, eaten foods, and overripe fruit—all were familiar symbols of life's impermanence. So were devouring insects and wilted blossoms.

Many still-life artists achieved an astonishing degree of illusion. The Dutch phrase *naer het leven* meant "from a live model"—and sometimes flower painters would wait entire seasons for a particular blossom to come into bloom. But it also described the work as being itself "lifelike." So compelling was their reality that poets described not only the beauty of still-life bouquets but the sweetness of their fragrance.

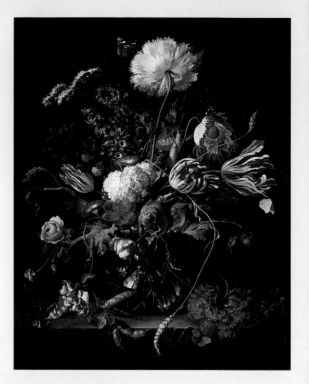

25 Jan Davidsz. de Heem, Dutch, 1606–1683/1684
*Vase of Flowers, c.*1660
oil on canvas
Andrew W. Mellon Fund

Although many still-life painters shared de Heem's concern with illusion, few matched his ability to recreate the tangible presence of things. Our senses are engaged: sight, smell, even touch. We can imagine the silkiness of these tulip petals or the papery thinness of a poppy. Yet this is not mimicry alone. The crosslike reflection in the vase is not accidental, and many other elements can also be understood symbolically. The butterflies, for example, point to Christ's Resurrection. Moreover, these blossoms—all so convincingly real—do not come into flower at the same time of year, and so this bouquet is one that de Heem could never have seen in real life. Though it relies on exact observation of nature, it also emphasizes the importance of the artist's imagination.

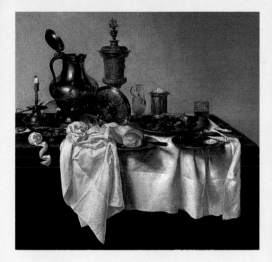

26 Willem Claesz. Heda, Dutch, 1593/1594–1680
Banquet Piece with Mince Pie, 1635
oil on canvas
Patrons' Permanent Fund

This is one of Heda's largest banquet pieces, and
the scale of the objects contributes to our sense
that they are real. The lemon peel and knife
handle seem even to project into our own space.
But they are not the remains of a real meal cap-
tured in paint. Contemporary audiences would
have seen the precarious platters, tipped goblets,
and snuffed-out candle as clear signals of life's
transience. And such reminders of mortality,
naturally, suggested man's need to be prepared
for final judgment, so there is a warning here as
well. While Heda's banqueters have enjoyed
exotic foods and oysters, commonly regarded as
an aphrodisiac, they left untouched a simple roll,
symbolic of the Eucharist bread.

The restricted colors—in this case tawny and
warm—are typical of the monochromatic still lifes
painted from the 1620 to the late 1640s. Later
Dutch still lifes were more brilliantly colored.

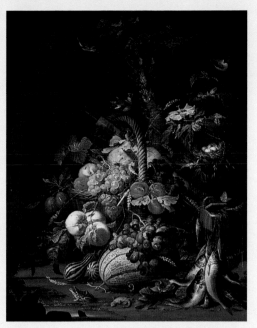

27 Abraham Mignon, Dutch, 1640–1679
Still Life with Fruit, Fish, and a Nest, c.1675
oil on canvas
Gift of Mr. and Mrs. H. John Heinz III

Massed here are fruits of the land and sea, crea-
tures of the sky and earth. In an egg-filled nest
and the march of ants over a dead lizard we find
the full cycle of birth and death. The miraculous
diversity of life was evidence of the richness of
God's creation, and Mignon's inclusion of wheat
and grapes might have suggested Communion
bread and wine. It is not always clear, though, how
many of the possible meanings were intended by
artists or "read" by their viewers. The notion of
abundance also had more secular significance.
The exotic species, trade porcelains, and rare shells
that are often seen in still-life paintings offered
patrons tangible evidence of Dutch mercantile
strength and their own success.

An early impetus to the development of still-
life painting—which emerged as an indepen-
dent genre more or less simultaneously in Italy,
Spain, and the Netherlands—had been the need
to record new varieties of plants and animals
brought back by explorers from the East Indies
and New World.

Jean-Louis Lemoyne | French, 1666–1755

28 *A Companion of Diana*, 1724
marble
Widener Collection

She is a companion of the hunt-goddess Diana, long-limbed and graceful, twisting with an eager, dancelike step to begin the chase. Pulling on the leash, the nymph looks down with warm affection at the hound who licks her bare thigh. This intimacy—tinged with playful eroticism—was a hallmark of rococo, and it shows Lemoyne to have been among the first sculptors to embrace the delicacy and lighthearted spirit of the emerging new style.

The National Gallery statue is probably Lemoyne's finest work. It was one of ten nymphs French king Louis XIV commissioned in 1710 from different artists. They were to be outdoor decorations for his favorite hunting château at Marly. The spirited forest-dwelling subject and relaxed atmosphere at Marly, where the king retreated from the formality of Versailles, may have encouraged Lemoyne's light touch. The project was among the old king's last, and it languished before his death; eventually this statue was installed in a château favored by Louis XV and his mistress Madame de Pompadour.

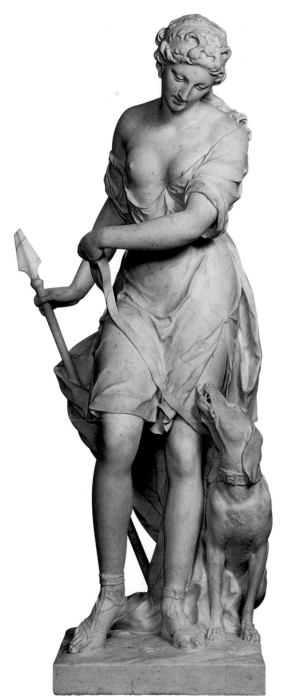

Jean Siméon Chardin | French, 1699–1779

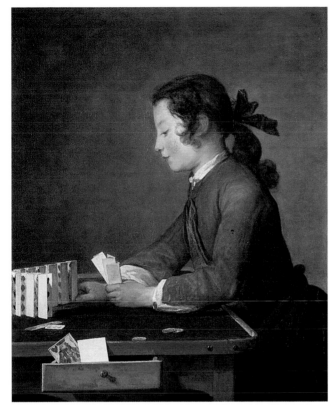

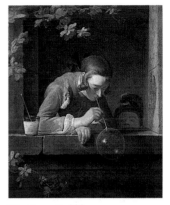

30 *Soap Bubbles*,
probably 1733/1734
oil on canvas
Gift of Mrs. John W. Simpson

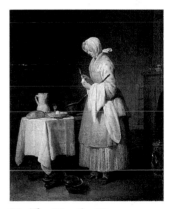

31 *The Attentive Nurse*,
probably 1738
oil on canvas
Samuel H. Kress Collection

29 *The House of Cards*, *c.*1735
oil on canvas
Andrew W. Mellon Collection

His apron marks him as a schoolboy or household servant, who is probably stealing a moment away from his tasks. The cards, bent to prevent cheating, have already been played, and the jack in the open drawer hints at knavery. Chardin is best known as a painter of still lifes, and this boy, intent on building a house of cards, has a similar breathless quiet. His absorbed concentration contrasts with the triviality and ultimate futility of his idle pursuit—and contemporary audiences would have understood immediately Chardin's gentle moralizing on this point.

In Chardin's *Soap Bubbles*, the message is the same: other young men devote themselves to producing a soap bubble, a commonly recognized symbol for the fragility of life itself. *The Attentive Nurse*, by contrast, offered an image of seriousness and dedication to duty.

Rococo

In 1715, when Louis XIV died after reigning more than fifty years, France was ready for art that pleased instead of impressed. Grandiloquence had well served the old king's imperial aspirations and the formality of Versailles, but now court life shifted back to Paris, where the new king's regent was a man known to enjoy his pleasures. Aristocrats built new, less imposing houses in town, and they began decorating them in a new style we call rococo. It emphasized pastel color, sinuous curves, and patterns based on vines, shells, and flowers. The new style was personal and intimate, relying on delicacy and charm. It was often playfully erotic. Grand themes from the Bible or ancient history were largely ignored in favor of lighter fare: mythological lovers, musicians and theater troupes, and gatherings of elegant young people in lyrical garden settings.

32 Antoine Watteau, French, 1684–1721
Ceres (Summer), 1715/1716
oil on canvas
Samuel H. Kress Collection

Watteau was the first painter to assemble all the ingredients of rococo—and this painting stands at the very cusp between old and new. Probably the design was sketched initially by another, older artist; Ceres' rather massive figure reflects that artist's more formal approach. It is the painting's shimmery brightness and fresh palette that look ahead to rococo's freer manner and more sensual surfaces.

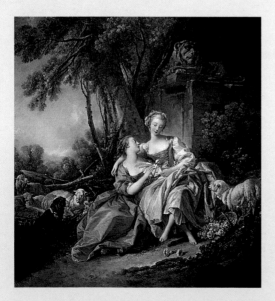

33 François Boucher, French, 1703–1770
The Love Letter, 1750
oil on canvas
Timken Collection

Idealized versions of country life were common on stage and were acted out in real-life masquerades by pampered young aristocrats. Silk dresses leave no doubt about the status of these "shepherdesses." Nor can this letter, delivered by a white dove, be anything but a love note. Contemporaries would have understood a clear erotic promise in the young woman's pink toes.

The Love Letter, originally oval in shape, was commissioned by Madame de Pompadour, Louis XV's influential mistress. Under her patronage, Boucher became the most fashionable artist in France.

34 Jean-Honoré Fragonard,
French, 1732–1806
A Young Girl Reading, c.1776
oil on canvas
Gift of Mrs. Mellon Bruce in
memory of her father, Andrew
W. Mellon

Fragonard was Boucher's most
talented pupil. He adopted his
teacher's lighthearted subjects
but painted in a freer style. Here,
the girl's dress and cushion are
created by surprising, fluid
movements. Her fingers are
quick swerves of the brush,
and the colors a startling mix
of saffron, magenta, and lilac.
Fragonard used the wooden tip
of the brush to scratch the ruf-
fled collar into the surface of
the paint. This is what contem-
poraries called his "swordplay
of the brush." In rapidly exe-
cuted paintings like this one,
his spontaneous brushwork
challenged traditional distinc-
tions between a sketch and a
finished work and becomes
itself the focus of the work.
 It is possible that Fragonard
painted this for his own pleasure.
It is not so much a portrait of a
reader as it is an evocation of
quiet solitude.

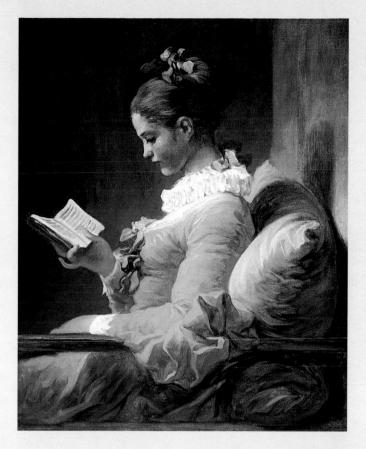

35 Etienne-Maurice Falconet,
French, 1716–1791
Venus of the Doves,
unknown date
marble
Samuel H. Kress Collection

Sculptors also responded to
patrons' desire for smaller
and more intimate works
such as this Venus, scaled for
a drawing room.

Jacques-Louis David | French, 1748–1825

36 *The Emperor Napoleon in His Study at the Tuileries*, 1812
oil on canvas
Samuel H. Kress Collection

It is past four o'clock in the morning in the Tuileries palace, and the emperor has been working into the small hours. David himself described the scene: "I have shown [Napoleon] in the condition most habitual with him—that of work. He is in the study, after a night spent composing his Code Napoléon . . ."

The artist was also at pains to explain that "everything in the picture, down to the smallest details of costume, furniture, sword, etc., was scrupulously modeled on [the emperor's] own." Their exactitude persuades us that the painting records a real place and time. The very clarity of the depiction imparts a kind of certitude.

Yet we know that the picture is an artful contrivance, an icon of Napoleon's public persona. The chair, for example, designed by David himself, was never used in Napoleon's study. And it is unlikely that the emperor actually posed—particularly since this portrait was commissioned by a Scottish nobleman, who sympathized with the French cause, while Britain and France were at war.

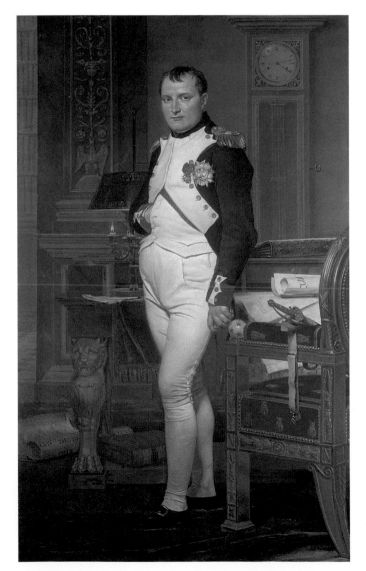

Jean-Auguste-Dominique Ingres | French, 1780–1867

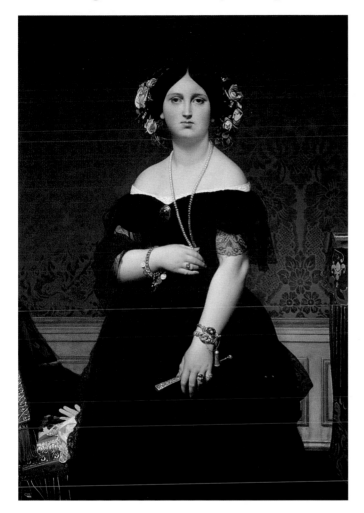

38 *Marcotte d'Argenteuil*, 1810
oil on canvas
Samuel H. Kress Collection

37 *Madame Moitessier*, 1851
oil on canvas
Samuel H. Kress Collection

She was newly married and considered a great beauty when Ingres, prompted by his friend Charles Marcotte, first agreed to paint Inès Moitessier.

His initial reluctance was overcome, he said, when confronted by her "terrible and beautiful head."

Ingres painted from life and was insistent about his sitter's costume and accessories. His mirror-hard style reproduces exactly the material finery that was emblematic of bourgeois society in mid-nineteenth-century France: the rich black of her lace and velvet ball gown, the gleam of gold and enameled jewelry. About the person who was Inès Moitessier we are less sure.

Juno-like, she has the remote and impassive bearing of an ancient goddess. Her gaze is unfocused, and she is abstracted by the emphatic line of her white shoulders despite the unrelenting realism of detail.

Joseph Mallord William Turner | British, 1775–1851

39 *Keelmen Heaving in Coals by Moonlight*, 1835
oil on canvas
Widener Collection

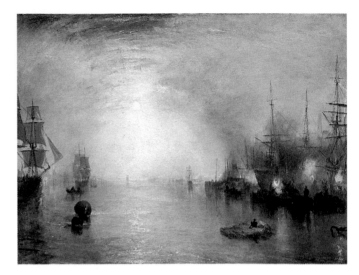

Turner translated into paint the overwhelming effects of nature. Men load coal into waiting vessels, but their shadowy figures are mere silhouettes on the margins of his picture. The center opens into a vortex of moonlight. Forms dissolve in this light; even the horizon is nearly subsumed in an incandescent tunnel.

Turner was intrigued by extremes of contrast—visual and otherwise. He paired this painting with one he had made in Venice the year before.

One scene is day, one night, one northern, the other southern. Along the gritty dockside of the River Tyne in the north of England Turner found evidence of his country's industry and growth, while reflected in the languid Venetian lagoon was a society in decline.

Contemporary and fellow painter John Constable described Turner's paintings as "airy visions, painted with tinted steam." Yet Turner's moisture-laden air only seems light. Although some parts of the canvas are thinly painted, other areas are thick with pigment. The moon stands out nearly in relief.

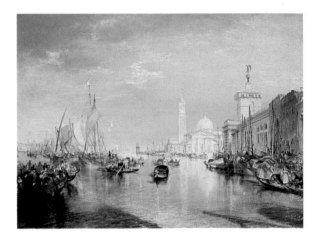

40 *Venice: The Dogana and San Giorgio Maggiore*, 1834
oil on canvas
Widener Collection

Winslow Homer | American, 1836–1910

41 *Right and Left*, 1909
oil on canvas
Gift of the Avalon Foundation

Considered a sporting picture in its own time and as a meditation on mortality in later scholarly analyses, *Right and Left* visualizes the cusp between life and death in the last moments of two goldeneye ducks. The male (left) and female (right) are poised in opposite positions like decorative motifs against a roiling sea. But look more intently at the dark water. Behind the second wave, a hunter in a boat and a tiny red dot identify the scene as ocean duck hunting. One blast of the hunter's double-barreled shotgun has already hit the female, who begins her downward plunge, while the male at left struggles to evade the shot from the other barrel.

There are two accounts of how Homer made this image. One noted that he went out, "day after day, in a boat with a man ... armed ... with a double barreled shotgun, and studied the positions and movements of the birds when they were shot."

Another claimed that the artist hired one of his neighbors in Prout's Neck, Maine, to row out to sea and fire blanks up at Homer while he stood on a cliff in the line of fire. Both explanations are plausible, as Homer himself was an experienced hunter whose images were generally based on first-hand observation.

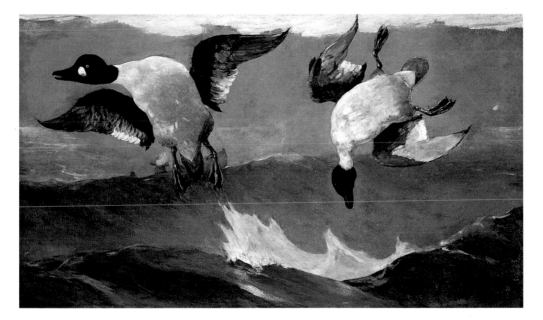

Dramatis Personae

John Singleton Copley | American, 1738–1815

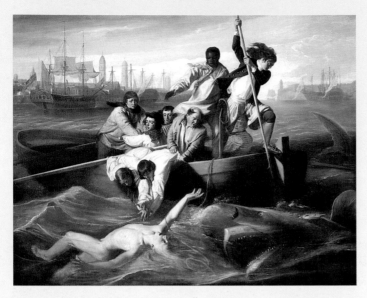

42 *Watson and the Shark*,
1778
oil on canvas
Ferdinand Lammot Belin Fund

This painting depicts a real event: the dramatic rescue at sea of Brooke Watson, a fourteen-year-old cabin boy attacked by a shark while swimming in Havana Harbor, Cuba, in 1749. He was saved by fellow sailors, but not before the shark tore off his right leg below the knee. Almost thirty years later, by then a leading merchant and political figure in London, Watson commissioned this record of his boyhood trauma. He selected Copley, a well-known Boston portraitist who had recently moved to London. Copley hoped to escape the tensions in America that would soon escalate into Revolutionary War and to work in England's infinitely more sophisticated artistic center. Copley's riveting portrayal of the shark attack won him great praise, and it remains an outstanding example of narrative painting.

Constructing a Narrative

Copley focused on the terrible moment before Watson's rescue, using composition itself to propel the action. It is Watson we see first. Pale and helpless in the water, he reaches up for salvation—to the men in the boat. He is tossed backward in waves churned by the shark as it makes its final, terrifying lunge at the boy. The upthrust of their colliding movements connects

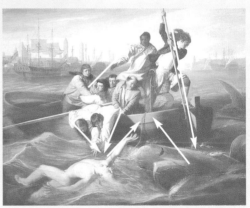

with the crew's desperate moves. Two reach down, forming a triangular wedge into the water, while another rows furiously to keep the rescue dinghy near. Above them, another triangular form rises with one sailor throwing out a rope (which eludes Watson's grasp) and plunges in the hands of another wielding a boat hook that will finally stop the predator. The diagonals of the composition, like the twisting, straining figures, suspend us in the horror of the scene.

43 *The Copley Family*,
1776/1777
oil on canvas
Andrew W. Mellon Fund

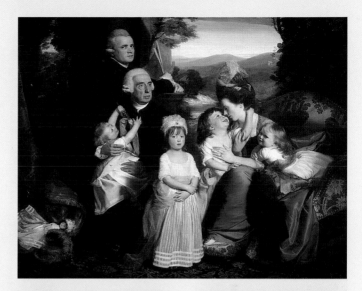

44 *Anne Fairchild Bowler*
(Mrs. Metcalf Bowler),
c.1763
oil on canvas
Gift of Louise Alida Livingston

45 *Epes Sargent*,
c.1760
oil on canvas
Gift of the Avalon Foundation

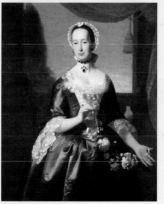
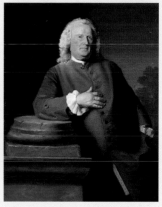

Master Portraitist

Copley's vivid, realistic portraits of wealthy Bostonians established his reputation in colonial America. That of Anne Fairchild Bowler demonstrates his mastery of color and texture—notice the stiff, shiny, blue silk dress trimmed with delicate lace and the brittle gleam of the sitter's sapphire necklace.

Epes Sargent's presence is a triumph of artistic strategy. Copley made the composition spare, the contrasts of light and shadow intense. Varying his brushwork, he painted Sargent's face, hands, and wig in heavy impasto to convey the wrinkles and roughness of age.

Located in a nearby gallery, *The Copley Family* celebrates the artist's reunion with his wife, children, and father-in-law in London. They had fled Boston, and Copley himself had returned from study and work in Italy (1774 to 1775). Like *Watson and the Shark*, the canvas includes a number of figures. Copley may have achieved their complex arrangement through study of baroque group portraits by Rubens and van Dyck. Yet the picture combines these European influences with the realism of his finest American work. The artist is pictured standing at left.

George Bellows | American, 1882–1925

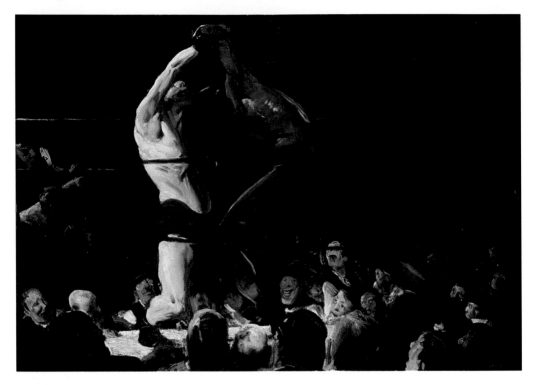

46 *Both Members of this Club*,
1909
oil on canvas
Chester Dale Collection

In 1909 public boxing was illegal in New York, but crowds could still see matches in the smoky backrooms of establishments such as Tom Sharkey's Athletic Club, which was located near Bellows' studio. This explosive scene is probably based on a bout the artist witnessed there. His ironic title makes note of the temporary club "memberships" that were sold to circumvent the law.

Bellows conveys the palpable violence of the fight—the straining muscles and powerful thrust of the apparent victor on the right, the bloodied face and slumping body of his opponent, even the faces of some spectators are distorted into brutish masks. The effect is multiplied by slashing brushstrokes and the harsh contrasts between light and dark. Yet, at least in the eyes of viewers today, by casting a black man as the victor—and giving him titanlike stature—Bellows seems also to be suggesting that the struggle is more than a physical one. The most brutal adversary is injustice.

Augustus Saint-Gaudens | American 1848–1907

47 Memorial to Robert Gould Shaw and the Massachusetts Fifty-Fourth Regiment, 1900
patinated plaster
U.S. Department of the Interior, National Park Service, Saint-Gaudens National Historic Site, Cornish, NH, on loan to the National Gallery of Art, Washington

This stirring monument honors the black soldiers and white colonel of the Massachusetts Fifty-Fourth Regiment—perhaps the most famous African-American military unit in the Civil War. Their 1863 assault on Fort Wagner, a heavily protected port guarding the seat of the Confederacy at Charleston, South Carolina, was immortalized in the film *Glory*. Their advance was met with a hail of fire. Half of the regiment's 600 troops were killed, wounded, or taken prisoner. The dead were thrown, with their felled leader, into a trench grave.

In sculpture, the cries and gunfire and death have yet to occur. The regiment surges forward to battle, with rifles, packs, and canteens peppering the scene of their march out of Boston, where they were recruited. Each man is mesmerizingly individual—the artist spent two years making clay studies to capture the diversity of African Americans who had volunteered. Two sons of Frederick Douglass. A dentist. A preacher. Boatmen and students. In friezelike procession, the men of the Fifty-Fourth are accompanied by an angel holding an olive branch (peace) and poppies (death, sleep, remembrance). Valor, sacrifice, and honor are incised in every detail of this plaster bas-relief. In bronze, it stands on Boston Common.

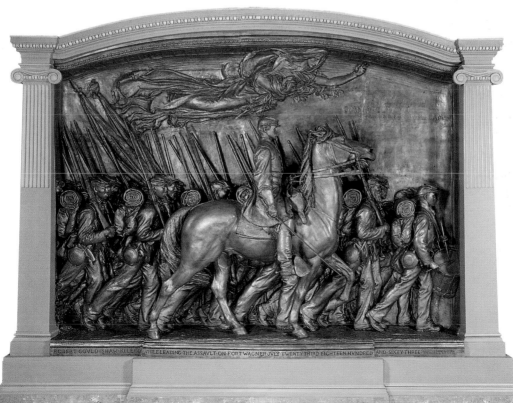

Painters of Modern Life

In 1863—eleven years before the first impressionist exhibition—French poet and critic Charles Baudelaire urged artists to abandon academic themes from history, religion, and mythology and to find their subjects in what he called the "heroism of modern life." The painter of modern life would turn to the urban landscape, to the bustling streets of Paris and its crowded night scene, concerning himself with "the ephemeral, the fugitive, the contingent." He would be unruffled by the confusion, speed, and uncertainties of modern life—these qualities would be matched, in fact, by his painting's immediacy and rapid execution.

Although Baudelaire had been writing specifically about Constantin Guys, a chronicler of Parisian fashion, it was Baudelaire's friend Edouard Manet who came to exemplify this new kind of modern painter. His subjects sometimes shocked. But Manet achieved a *succès de scandale* and by the 1870s was accepted as a leader of the avant-garde. Artists Degas, Cassatt, and Toulouse-Lautrec, among others, also probed the life of the city from its rough dance halls to its sophisticated cafés and spectacles.

48 Edouard Manet, French, 1832–1883
Masked Ball at the Opera, 1873
oil on canvas
Gift of Mrs. Horace Havemeyer in memory of her mother-in-law, Louisine W. Havemeyer

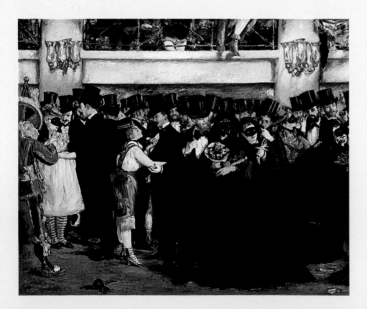

Here is the urbane Parisian world Manet loved: a masked ball at the old opera. There is little doubt about the openly sexual nature of the encounters between scantily clad members of the demimonde and well-dressed young men. Adventurous upper-class women—in masks—have also ventured onto the floor. In the center one stands as a kind of black-clad "bride" with a bouquet. Note that figures end abruptly at the edges. At top a leg dangles over a railing. We are instantly aware that we see only a part of this busy scene and that life extends beyond the picture frame. In a moment all will have changed.

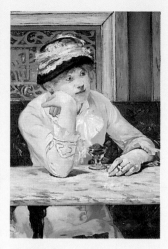

49 Edouard Manet
Plum Brandy, c.1877
oil on canvas
Collection of Mr. and Mrs. Paul
Mellon

The painter of modern life
was part detective. Take this
young woman. She is alone
and pensive. Her cigarette
remains unlit and her
brandied plum untouched
as she lingers in a café.
Respectable middle-class
women did not smoke in
public, or sit alone. It is
possible she is a prostitute.
Or maybe her demure dress
and pleasant face mark her
as a *grisette*, one of Paris'
legions of single shopgirls
struggling to live in the city.

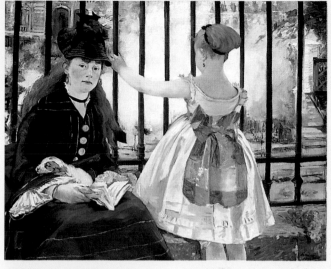

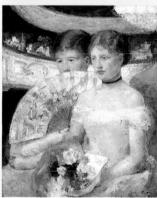

50 Mary Cassatt
American, 1844–1926
The Loge, 1882
oil on canvas
Chester Dale Collection

At the theater, the action on
stage was rivaled by audience
watching in the auditorium.
These two young women
appear to be sitting in orches-
tra seats, but the balcony rows
behind them are actually
reflections from the mirrored
wall of their box. Proper ladies
did not sit in the orchestra.

51 Edouard Manet
The Railway, 1873
oil on canvas
Gift of Horace Havemeyer in
memory of his mother, Louisine
W. Havemeyer

There is perhaps no more
powerful image of modern
life. Manet's pivotal work,
The Railway, pays homage to
the bustling city of Paris,
where he lived and worked—
and to his artistic career—
suggested by the door to his
house and studio in the left
background and the figure of
his regular model, Victorine
Meurent, left front. The
strangely blank center of the
image is actually a cloud of
steam or smoke under which
train lines and a signalman's
hut indicate the nearby Gare
Saint-Lazare. Manet's studio
overlooked the tracks out of
Saint-Lazare, which handled
forty percent of all Parisian
rail travelers.

Vincent van Gogh | Dutch, 1853–1890

52 *Self-Portrait*, 1889
oil on canvas
Collection of Mr. and Mrs. John
Hay Whitney

In the brief ten years of his career, van Gogh made almost 2,000 paintings and drawings and wrote more than 800 letters chronicling his aims and struggles as an artist. His self-portraits, approximately thirty- five in all, extend the dialogue he pursued in search of personal realization and aesthetic achievement. After several false starts in Holland and England, van Gogh mastered the impressionist style while living in Paris. Soon exhausted from urban life, he moved to the south of France in 1888, residing first in Arles, then in St.-Rémy. The intense light and colors of Provence inspired a period of activity during which van Gogh worked feverishly, painting some of his most famous compositions but also experi- encing emotional breakdowns. He made this self-portrait after committing himself to an asylum in St.-Rémy. Flame-like hatches of blue pigment sur- round the artist, contrasting with his red beard and hair and setting off his face, starkly realized in drags of green pig- ment over flesh tones. Holding palette and brushes, the artist's penetrating eyes and wavering contours express the fervor and fragility that defined his short life.

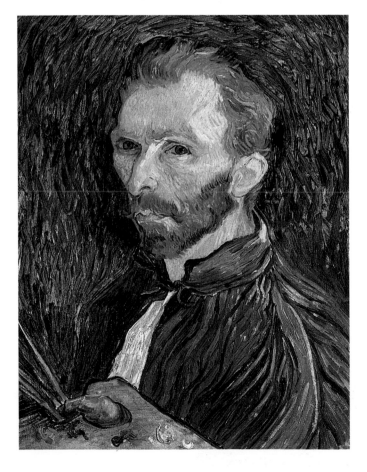

Paul Gauguin | French, 1848–1903

53 *Parau na te Varua ino*
(Words of the Devil), 1892
oil on canvas
Gift of the W. Averell Harriman
Foundation in memory of Marie
N. Harriman

In 1891 Gauguin moved to Tahiti hoping to find an unspoiled culture, an exotic and sensual world where life forces were close to the surface. Instead it was an island already transformed by Western missionaries and colonial rule, and Gauguin largely had to invent the world he sought, interweaving images from island mythology with ones from European and other cultures.

The masked kneeling figure with the burning eyes is the *varua ino* of the title, a malevolent spirit. The standing woman is linked by her gesture of modesty with the biblical Eve, but this is not simply a Western theme in Polynesian dress. The Polynesian Eve does not embody shame or guilt but is a conduit for spiritual energy to enter the world. Probably for Gauguin she represented knowledge of good and evil, life and death, questions that preoccupied him. At the upper right, he included himself in the scene with the depiction of a sketchy hand, an emblem that he had used in self-portraits.

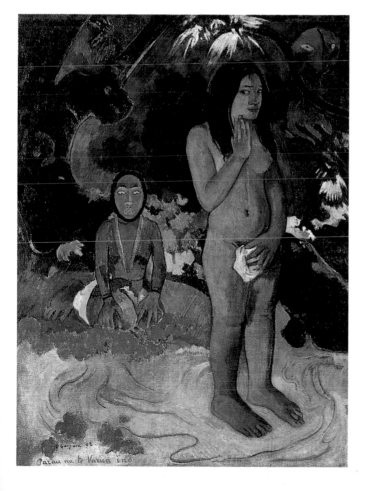

Along the Seine

From the 1860s on, artists seeking fresh images of life and nature often lived and worked in hamlets along the Seine. The river became the destination of commuters and weekend day-trippers, and was used by various industries. One novel of the period described the Seine, increasingly marked by industrial parks and boat centers as well as picturesque gardens and vacation villas, as "dirty and sparkling, miserable and gay, popular and alive." The description alerts us to the Seine's amalgam of town and country, where sailboats raced past commercial barges, and the loading of cargo (gypsum, for example) was as typical as the loading of passengers in canoes.

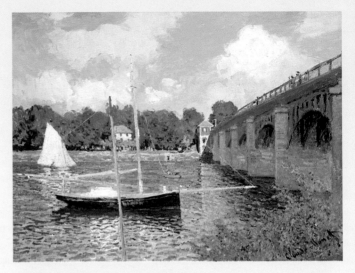

54 Claude Monet, French, 1840–1926
The Bridge at Argenteuil, 1874
oil on canvas
Collection of Mr. and Mrs. Paul Mellon

Monet lived in Argenteuil on and off for nearly six years in the 1870s, painting its boating life, industry, fields, and gardens. Here sailboats signal the town's yachting life. Short touches of pigment in the water suggest the regular winds that made this deep part of the Seine good for sailing. At right is one of the highway bridges that crossed the river at various suburban towns. On the far bank is the bridge's toll-house and, to its left, a café.

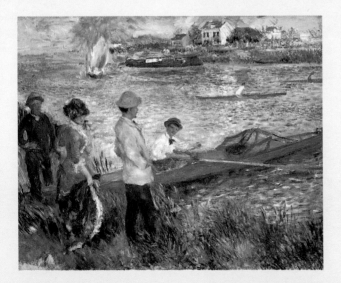

55 Auguste Renoir, French, 1841–1919
Oarsmen at Chatou, 1879
oil on canvas
Gift of Sam A. Lewisohn

Chatou was the Seine's rowing center. Details suggest the activities at this town close to Paris. The orange gig on the shore was meant for a rower and a facing passenger. Across the river, a commercial barge drifts in front of an inn catering to weekend revelers. Renoir's saturated orange and orange-reds set against blues and greens denote full sunlight, his dashes and drags of pigment, the quintessential impressionist technique.

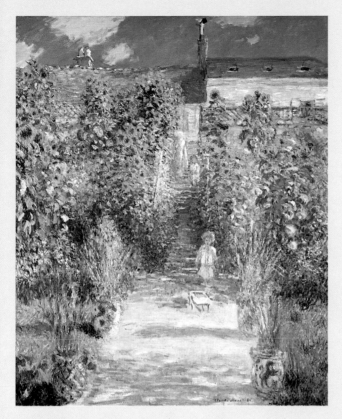

56 Claude Monet
The Artist's Garden at Vétheuil,
1880
oil on canvas
Ailsa Mellon Bruce Collection

Monet was a passionate gardener.
At Vétheuil, where he lived from
1878 to 1883, he arranged to gar-
den on a parcel of land located
across the road from his rented
house. Monet flanked the steeply
sloped plot with sunflowers and
lined the path with gladioli (from
nearby Argenteuil) in oriental
vases. Brilliant sunlight is dappled
with shadows across the garden
path, conjured in blues, plums,
and greens.

57 Claude Monet
The Japanese Footbridge, 1899
oil on canvas
Gift of Victoria Nebeker Coberly, in
memory of her son John W. Mudd,
and Walter H. and Leonore Annenberg

From 1883 until his death, Monet
lived in a converted farmhouse on
several acres at Giverny, farther
down the Seine. There, he cultivated
spectacular gardens and built a
pond that he planted with water-
lilies and later ornamented with a
Japanese footbridge. In this, one in
a series of eighteen views of the pond
he made in 1899, Monet eliminated
sky and chose a low vantage point
that immerses us in the pond
enclosure. His prized *nymphéas*,
painted with horizontal drags of
mauve and white pigment, float
amid reflections of border plantings
painted in choppy, vertical strokes
of green, blue, and brown.

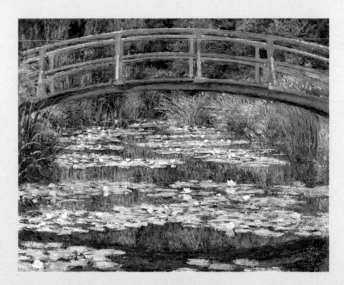

Paul Cézanne | French, 1839–1906

58 *Boy in a Red Waistcoat*,
1888–1890
oil on canvas
Collection of Mr. and Mrs. Paul
Mellon, in Honor of the 50th
Anniversary of the National
Gallery of Art

"Cézanne's art," one critic wrote,
"lies between the old kind of
picture, faithful to a striking or
beautiful object, and the mod-
ern 'abstract' kind of painting,
a moving harmony of color

touches representing nothing."
This painting is both connected
to the past and breathtakingly
fresh and new.

The pose is a familiar one
from the type of life-study
classes that dominated training
in the conservative academy.
The boy, in the vest of an Italian
peasant, projects the elegance
of a sixteenth-century portrait.
On the other hand, it is easy to
see this "portrait" as something
that exists most essentially as

shapes and colors. Cézanne
said he was seeking a "harmony
parallel to nature." In the back-
ground, a chair and draperies
shatter into so dizzying a pat-
tern that it is difficult, at first,
to read them. They look forward
to the reconstructed pictorial
space of the cubists Braque and
Picasso.

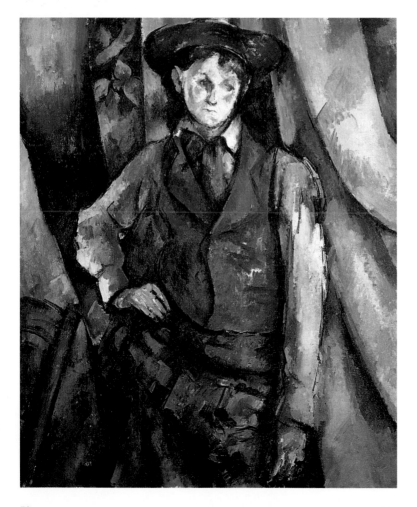

Edgar Degas | French, 1834–1917

59 *Scene from the Steeplechase: The Fallen Jockey*,
1866, reworked 1880–1881 and *c.*1897
oil on canvas
Collection of Mr. and Mrs. Paul Mellon

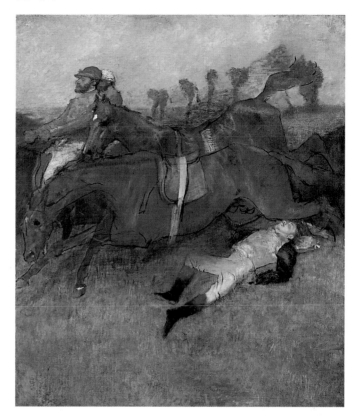

Horse riding, racing, and the steeplechase were all the rage among the Parisian upper class in the middle and late decades of the nineteenth century. In addition to the Longchamp racetrack in Paris, opened in 1857 in the city's rebuilt Bois de Boulogne (formerly a royal park), there were racecourses and racing events at other locations in Paris and in the French countryside. Degas, a passionate observer of every aspect of modern life, was fascinated by the spectacle of horses and riders, especially at the racetrack. Often he focused on a moment before or between races, capturing the tension, risk, or distraction inherent in different stages of the event.

The Fallen Jockey was his largest racing picture and one of his earliest, exhibited at the Salon of 1866. Here, the speed and danger of the steeplechase are made frighteningly clear by the rider lying in the foreground under his own mount and possibly under the path of a second, riderless horse. Both animals threaten to thunder over him, their forward rush a pictorial drama fueled by Degas' constricting composition and his use of sketchy, almost nervous areas of high color. It is not surprising that Degas would present a scene of grave injury—perhaps death—for the steeplechase is a daunting obstacle course in which horse and rider gallop across fields and attempt to clear stone walls, ditches, water jumps, and hedges en route to a church steeple or another landmark at the end of the course. In Degas' time (and often today), steeplechase riders were gentlemen, not professional jockeys. The combination of high speed, perilous terrain, and amateur riders was, for some, a formula for disaster. Degas reworked this canvas several times later in his career, which accounts for its sketchy, unfinished appearance.

Edgar Degas' Wax Sculpture

Edgar Degas | French, 1834–1917

Although he exhibited only one work of sculpture in his lifetime, Degas made sculpture almost from the beginning of his career—in wax. Like his paintings and works on paper, the waxes treat themes of the ballet, horse racing, and the figure in contemporary contexts. The National Gallery holds forty-eight of the seventy wax sculptures salvaged from Degas' Paris studio nearly a century ago.

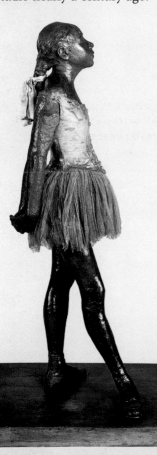

60 *Little Dancer Fourteen Years Old (Petite danseuse de quatorze ans)*, 1879–1880
yellow wax, hair, ribbon, linen bodice, satin shoes, muslin tutu, wood base
Collection of Mr. and Mrs. Paul Mellon

Her pose is brash, almost defiant, her eyes half closed and jaw uptilted in self-absorption. Her arms and legs stretch from her torso to hold an open fourth position—hence the back thrust of her shoulders and wrists held behind her. At once elegant and awkward, *Little Dancer* is the only sculpture Degas exhibited during his lifetime—at the sixth impressionist exhibition in 1881. That Degas dressed her in miniature clothes and a wig caused one critic to call her a specimen, not art. Further blurring the line between realism and artifice, Degas used his unconventional tinted wax to approximate skin flushed with muscular exertion, then applied thin coats of colored wax over the hair, clothes, and tiny shoes to reassert the surface of the statuette.

"...THE ONLY TRULY MODERN ATTEMPT I KNOW IN SCULPTURE."
Joris-Karl Huysmans, novelist and critic

61 *The Tub*, 1889
brownish red wax, lead, plaster of paris, cloth
Collection of Mr. and Mrs. Paul Mellon

The Tub exemplifies Degas' potent observation of subject from oblique points of view. Rounded and delicate from a sidelong perspective, it is roughly volumetric and sensual seen from above. Degas achieved astonishing effects of color and texture with mixed media. The female nude, made of darkened red beeswax, lies in water conjured of plaster. Her tub, suggested by a strip of metal, is set on a base of plaster-soaked cloth. With one arm partially submerged, the other reaching her toes, she is roughed and pressed into being—like the cloth base under her tub and the slightly churned water—by Degas' visible touch.

"I MADE A BASE FOR IT WITH RAGS SOAKED IN . . . PLASTER."
Degas

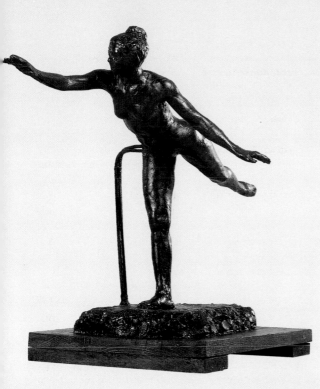

63 *Grande Arabesque, Second Time*
*c.*1882/1895
brown plastilene, wax, cork
Collection of Mr. and Mrs. Paul Mellon

Accustomed to using everything from wine-bottle and mustard-jar corks to long nails as filler inside his sculpture, Degas was also highly experimental with armatures, and supports were often placed outside his works. Here the armature holds the tensed energy of the arabesque, in which a dancer balances on one leg while raising the other simultaneously with her arms.

"DANSE, GAMIN AILÉ..."
from a Degas sonnet

62 *Horse Balking (Horse Clearing an Obstacle)*, 1880s
yellow wax
Collection of Mr. and Mrs. Paul Mellon

The tensed energy and physical prowess of horse racing fascinated Degas, much like the ballet. To achieve this convincing image of a horse, Degas evokes a variety of directional movements. Front legs rise, back legs spread as if bracing, while the animal simultaneously twists. The daring vitality of *Horse Balking* was informed, in part, by Degas' study of Eadweard Muybridge's photographs of animal loco-motion (published in 1887 and referenced by Degas in a notebook). Equally relevant, however, were the artist's razor-sharp observation of the thorough-bred and his visceral modeling of the wax figure.

"TO ACHIEVE EXACTITUDE IN THE REPRESENTATION OF ANIMALS ONE HAD TO GO INTO THREE DIMENSIONS."
Degas

Henri Matisse | French, 1869–1954

64 *Open Window, Collioure*,
1905
oil on canvas
Collection of Mr. and Mrs. John
Hay Whitney

Pink waves, a sky of turquoise, pink, and periwinkle, reflections of watery cyclamen: these are hardly the colors of nature, and they provoked an outrage when this and similar works by Matisse, Maurice de Vlaminck, André Derain, and others were first exhibited at the Salon d'Automne in 1905.

A critic, noting the works' proximity to a Renaissance-style statuette, quipped "Tiens, Donatello chez les fauves" (Well, well, Donatello among the wild beasts). Soon, these artists were being called the fauves, and though fauvism itself was short-lived, its influence was not. The Salon d'Automne afforded one of the first looks at what twentieth-century art would be.

The fauves liberated color. It was not nature but art that determined their selection. "When I put a green," Matisse later said, "it is not grass. When I put a blue, it is not the sky." He was painting pictures, not things. No longer limited by imitation, color expressed the artist's intention and emotion.

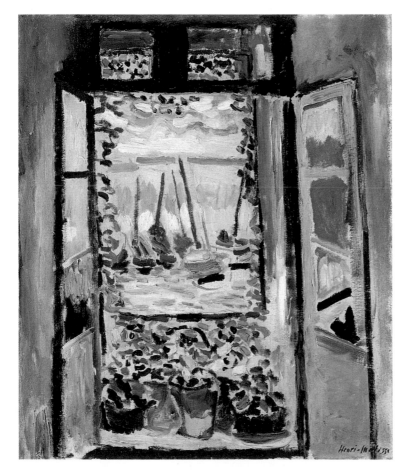

Wassily Kandinsky | Russian, 1866–1944

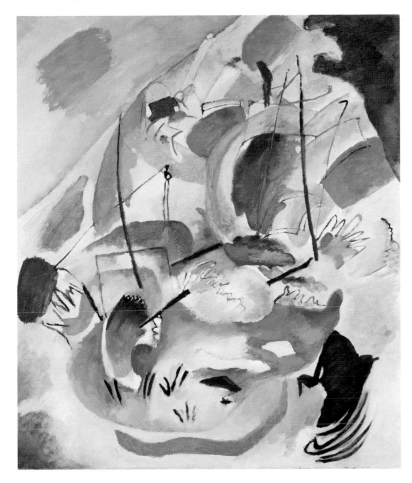

65 *Improvisation 31 (Sea Battle)*, 1913
oil on canvas
Ailsa Mellon Bruce Fund

Two tall-masted ships are locked in combat. They blast each other with cannon fire while floating in a "sea" of color forms. Tension is created through the pointed black masts and the opposing areas of color. Large yellow and vermilion triangular shapes at the top both contain the action and provide a platform for it. This otherworldly realm represents, as the artist stated, "a terrible struggle ... going on in the spiritual atmosphere." Kandinsky believed—along with theosophists such as Rudolph Steiner and Annie Besant, who interpreted the Book of Revelation—that a great earthly cataclysm would bring a new spiritual age. Kandinsky was one of the first artists of the twentieth century to explore abstraction in paint.

His work liberated line and color from their conventional role of describing reality. For him, painting was a mystical act that brought inner spirituality into visible form.

Arshile Gorky | American, 1904–1948

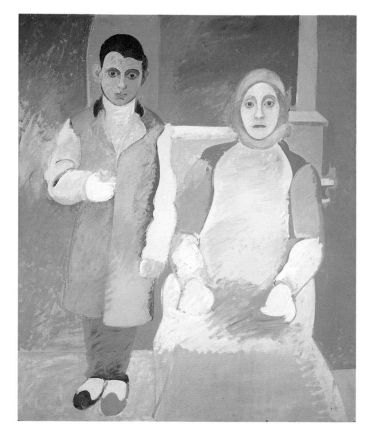

66 *The Artist and His Mother*,
*c.*1926/1936
oil on canvas
Ailsa Mellon Bruce Fund

Years after the 1915 Turkish campaign against Armenians caused Gorky's family to disperse and his mother to die of illness and starvation before his eyes, the artist found the photograph upon which he based this portrait. The clock is turned back. Gorky is eight, standing beside his mother, Shushan, in a portrait studio. Soon

after, Gorky and his relatives became refugees in chaos, fleeing ethnic genocide. After his mother's death, Gorky emigrated to America and eventually gained recognition as an abstract painter in New York. His art, however, remained rooted in the visual and emotional memories of a childhood in rural Armenia.

The Artist and His Mother was a subject that absorbed Gorky for years. It is painted in broad areas of expressive color usually associated with modernist sensibility, yet it

also bears the frozen, timeless air of a medieval icon. Its surface is smoothly polished (take a sidelong view)—the result of Gorky's applying layer upon layer of thinned oil paints, which, when each was nearly dry, he scraped or sanded until flat. These burnished passages contribute to a fragile, veiled quality particularly obvious in the face of Shushan, who appears like a posthumous vision, loved and lost.

Alberto Giacometti | Swiss, 1901–1966

67 *The Chariot*, 1950
bronze
Gift of Enid A. Haupt

Jean-Paul Sartre said of his friend Giacometti's figures that each one seems "to secrete its own void." It easy to imagine that Giacometti's attenuated shapes are poised between "being and nothingness," and they have often been interpreted in terms of existentialist isolation and angst. Yet Giacometti was most concerned with vision, with perception and how it is modified by physiological and psychological effects. His struggle was to see and to fix what he saw in space. Apprehending a whole figure,

he realized, requires a certain distance. In one sense, the thinness of Giacometti's forms incorporates the effect of this distance.

Most of Giacometti's figures are the product of long, intense looking, but he said that *Chariot* was an image that had been presented to him whole, already formed in his mind. It stemmed from his memory of a wheeled pharmacy cart he had seen during a hospital stay in 1938. The statue was commissioned for a French park but rejected.

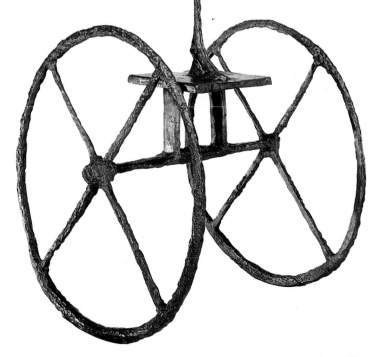

Family of Saltimbanques

Pablo Picasso | Spanish, 1881–1973

This image of circus performers set against a barren terrain was the largest and most important painting Picasso made during his early, struggling years as an artist. Rather than depicting action, Picasso used the saltimbanques to represent the melancholy of the neglected artist. Like these vagabond comedians, consigned to the bleak fringes of Paris when not performing, Picasso had been living like a transient for the previous five years, sleeping in other artist's rooms, often near starving. The French had created a term—*la bohème* —specifically for the dispossesed, buffeted souls Picasso and his subjects typified. The harlequin on the left, his head in profile and his hand turned back —showing you his palm— is Picasso himself.

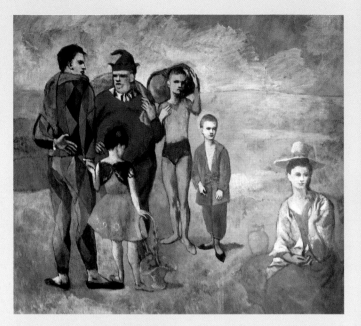

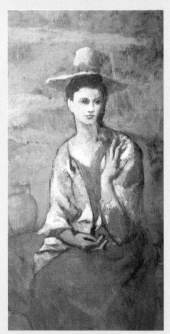

68 *Family of Saltimbanques*,
1905
oil on canvas
Chester Dale Collection

By the time he began the *Saltimbanques*, Picasso had an apartment in a dilapidated building in the Parisian neighborhood of Montmartre. He was becoming an artist of some note, with a band of creative friends. The poet Guillaume Apollinaire visited him almost daily during the year 1904–1905 while Picasso worked on the painting. It was Apollinaire who called Picasso the Harlequin Trismegistus, the magician-trickster on the first card in the Tarot, perhaps inspiring Picasso to portray himself in harlequin's diamond-printed costume.

Picasso and his friends were habitués of the circus, primarily at the local Cirque Medrano. The rotund jester has been identified as the Spanish clown El tío Pepe don José, who performed there and who, like other clowns, fascinated the artist. But neither he nor the other figures tumble or juggle or jest. Instead, they are still, their gazes held in perpetual disconnect, their identities frozen as social outsiders in the same way that Picasso envisioned himself.

The scene's stark backdrop is an abstracted version of the *terrain vague* on the outskirts of Paris. Its haunting quality enforces the melancholy tone of the *Saltimbanques*, as does the painting's subdued palette of chalky red hues. Although this tonality signifies Picasso's Rose period work, the *Saltimbanques'* original coloration was bluish. In successive stages—there are four other states beneath the picture's final form—Picasso switched from blue to rose, consciously allowing the blue paint to show through as he reworked the canvas. In this way, he created contour as well as a dusky, veiled atmosphere. Note the way drags of blue paint penetrate the pinkish figure of the boy holding a drum and glance the edges of almost every face. In his handling of paint and surfaces, Picasso left nothing to chance.

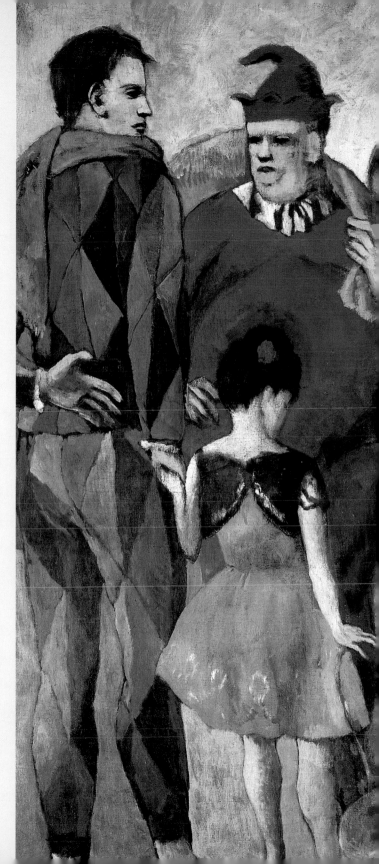

Jackson Pollock | American, 1912–1956

69 *Number 1, 1950 (Lavender Mist)*, 1950
oil, enamel, and aluminum on canvas
Ailsa Mellon Bruce Fund

In the late 1940s Jackson Pollock started a group of large-scale canvases that would rock the art world. He positioned these works flat on the ground, dripping and pouring his paints while walking around his canvases. Pollock's approach (often called action painting) created layered, overall compositions. *Lavender Mist* is among the best examples of Pollock's then radically new work. It contains no lavender (its title was suggested by an art critic), but radiates a lavender glow from its arced and interlaced webs of black, white, russet, orange, silver, and stone blue industrial paints. Involving himself physically as well as intellectually in the making of art, Pollock acted almost as a "medium" in the creative process by transferring vital emotional and artistic energies to his images. It was almost a ritual process, and like an ancient shaman, Pollock "signed" *Lavender Mist* at the upper left corner and at the top of the canvas with his handprints.

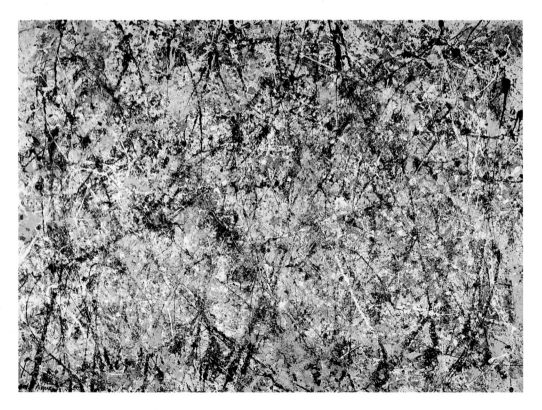

Roy Lichtenstein | American, 1923–1997

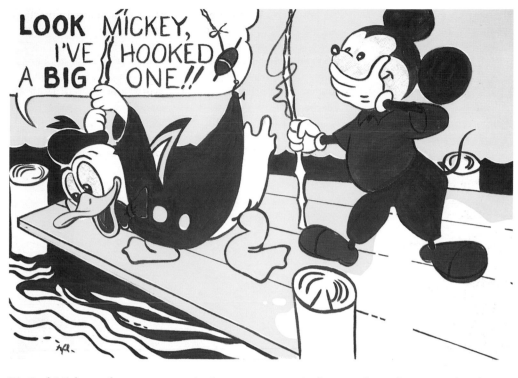

70 *Look Mickey*, 1961
oil on canvas
Dorothy and Roy Lichtenstein,
Gift of the Artist, in Honor of the
50th Anniversary of the National
Gallery of Art

Look Mickey parodies a cartoon
that is a cultural icon, creating
an ironic tension that exemplifies pop art. The irascible
Donald Duck, true to type,
thinks he has caught a big fish
when he has merely hooked
his own coattail. Mickey
Mouse, seeing his friend's

mistake, suppresses a giggle.
The gag image, however, is not
quite the comic strip rip-off it
seems at first glance. It simulates the Benday printing
process of comics, but magnifies its ink-dot appearance to
near parody. The painting also
limits color to the primaries
red, blue, and yellow, and with
constricted range and areas
left "uncolored," extends the
pique of context Lichtenstein
intended. Artistry wrestles
with technology, the lofty subjects of painting with cartoon

plot. Lichtenstein's breakthrough works of the early
1960s, such as *Look Mickey*,
ushered the contemporary
marketplace into the world
of art, storming the barriers
between high and low culture.

Martin Puryear | American, born 1941

71 *Lever No.3*, 1989
carved and painted wood
Gift of the Collectors Committee

This abstract sculpture is a graceful giant, its lithe soul unfurling like a tendril. The exquisite form and open associations of the work epitomize the artist who made it. Martin Puryear grew up in Washington, D.C. As a boy, his passions were nature and wildlife, and he built useful objects for himself, including a guitar that he could take apart and reassemble. He was already skilled in woodworking when he graduated from college and joined the Peace Corps. In Sierra Leone for two years (guitar in tow), he learned the African approach to carpentry—hand wrought, deeply respectful of materials. Puryear pushed on to Stockholm with a scholarship for graphic design studies at the Swedish Royal Academy of Art. He was drawn to the basketry and other crafts of the Arctic (where he backpacked) and to the materials and techniques of Scandinavian woodcrafting. He returned to America deeply interested in wood sculpture.

Lever No. 3 is made of stacked pieces of ponderosa pine, which Puryear layered, carved, and painted black. Its surfaces, faintly faceted, and its color, evoking the ancient arts of dyeing and smoking materials, carry the wealth of sources that inform Puryear's art.

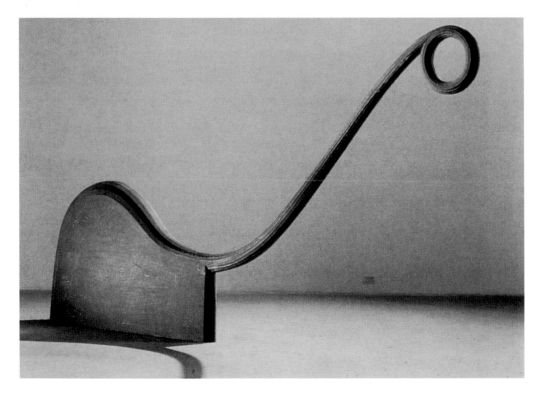

Louise Bourgeois | American, born 1911

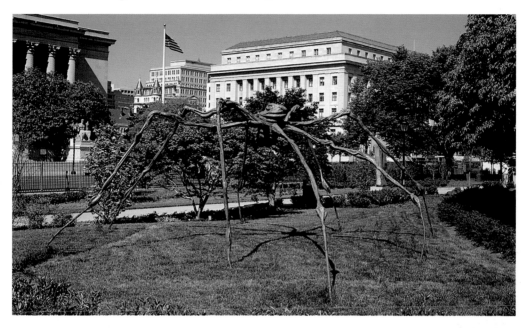

72 *Spider*, 1996, cast 1997
bronze with silver nitrate patina
Gift of The Morris and
Gwendolyn Cafritz Foundation

In 1994 Louise Bourgeois began making a number of spider pieces, showing them in 1997 in an exhibition titled *Ode à ma mère* (Ode to my mother). Her spiders are not predatory but maternal, vulnerable yet nurturing and protective of their young. Because Bourgeois' own mother ran the family's tapestry repair business, her identification with web-spinning arachnids might be more appropriate than first appears. Images of spiders are found in Bourgeois' earliest prints and drawings, and so this "thread" is also a connection to her past and to memory. Bourgeois explores her role as daughter, not as mother herself. Tensions she felt in childhood between her mother's love and what she regarded as her father's betrayal have shaped her work for six decades. Bourgeois communicates her psychological motivations with powerful forms that seem to have the interior force of ritual objects.

Claes Oldenburg | American, born 1929
Coosje van Bruggen | American, born 1942

73 *Typewriter Eraser, Scale X*, model 1998, fabricated 1999
stainless steel and cement painted with acrylic urethane
Gift of The Morris and Gwendolyn Cafritz Foundation

Before computers, we wrote on typewriters and used round, bristled erasers to eliminate mistakes. Oldenburg remembers the typewriter eraser from time spent in his father's office. This twenty-foot sculpture of the now obsolete tool is his paean to things commonplace yet significant, presented in large scale to impress upon us the ironic connections between art and life. Its antic lean and red rubber wheel almost promise to roll around the museum's sculpture garden like a frisky, runaway toy. That's fine with Oldenburg, who invests his work with subversive protest, wry nostalgia, and mischievous erotic allusions. Oldenburg's early "soft sculptures" of everyday items such as ice-cream cones, cigarettes, and bathroom fixtures, often made of cloth or vinyl, led to large-scale projects like *Typewriter Eraser, Scale X*, undertaken with his wife, Coosje van Bruggen. Note that this glass fiber and resin sculpture is covered with the same kind of red coating used on tennis courts and running tracks.

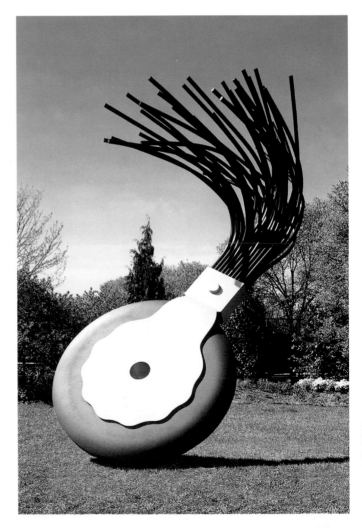

NATIONAL GALLERY OF ART, WASHINGTON

Sculpture Garden and Symbol Key/Jardin de sculptures et légende/ Jardín de esculturas y clave de símbolos

Men's Restroom (disabled access may require assistance)
WC hommes (accès difficile pour certains handicapés)
Lavabos de caballeros (el acceso podría resultar difícil para las personas minusválidas)

Women's Restroom (disabled access may require assistance)
WC femmes (accès difficile pour certains handicapés)
Lavabos de señoras (el acceso podría resultar difícil para las personas minusválidas)

Accessible Restroom (for visitors requiring assistance from their companions)
WC accessible aux handicapés (notamment ceux ayant besoin de l'aide de leur accompagnateur)
Lavabos de fácil acceso (para visitantes que requieran asistencia de sus acompañantes)

Checkroom/Vestiaire/Guardarropa

Art Information/Informations concernant les œuvres/Información sobre las obras de arte

Telephone/Téléphone/Teléfono

First Aid/Poste de secours/Primeros auxilios

Assistive Listening Device/Appareil auditif pour malentendants/Dispositivo para personas con dificultades auditivas

Elevator/Ascenseur/Elevador

Facility for the Disabled/Accessible aux handicapés/Instalaciones para personas minusválidas

Escalator/Escalator/Escaleras mecánicas

Café or Food Service/Café ou service de restauration/Cafetería

(73) Objects mentioned in text. Consult ❓ for updated locations
Objets mentionnés dans le texte. Consultez ❓ pour les localiser
Objetos mencionados en el texto. Consultar el símbolo ❓ para información actualizada sobre la ubicación de las obras

* Not on view 4/01–2/02/Pas exposé 4/01–2/02/No están en exhibición de 4/01 a 2/02

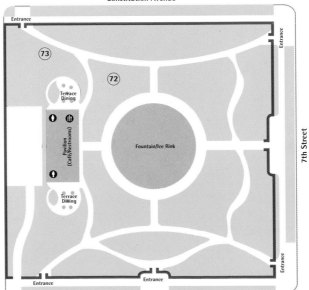